ANIMAL BABIES

1 3 5 7 9 10 8 6 4 2

BBC Books, an imprint of Ebury Publishing
20 Vauxhall Bridge Road, London SW1V 2SA

BBC Books is part of the Penguin Random House group of companies
whose addresses can be found at global.penguinrandomhouse.com

Penguin
Random House
UK

This book is published to accompany the television series
entitled *Animal Babies* first broadcast on BBC One in 2016.

Executive producer Vyv Simson
Series producer Gavin Boyland
BBC Commissioning editor Lucinda Axelsson

First published by BBC Books in 2016

www.penguin.co.uk

A CIP catalogue record for this book is available from the British Library

ISBN 9781785941009

Commissioning editor Albert DePetrillo
Project editor Grace Paul
Cover design Clarkevanmeurs Design
Designer Jim Smith Design Ltd
Picture researcher Laura Barwick
Image grading Stephen Johnson, Copyrightimage
Production Helen Everson

Jacket photographs
FRONT: Suzi Eszterhas / Minden Pictures / FLPA
BACK (from left to right, top to bottom): Klein & Hubert / naturepl.com;
Katherine Feng / Minden Pictures / FLPA; Anup Shah / naturepl.com;
Suzi Eszterhas / Minden Pictures / FLPA; J.-L. Klein and M.-L. Hubert / FLPA; ARCO / naturepl.com

Colour origination by Altaimage, London
Printed and bound in Italy by Printer Trento

MIX
Paper from
responsible sources
FSC® C018179

Laura Barwick

BOOKS

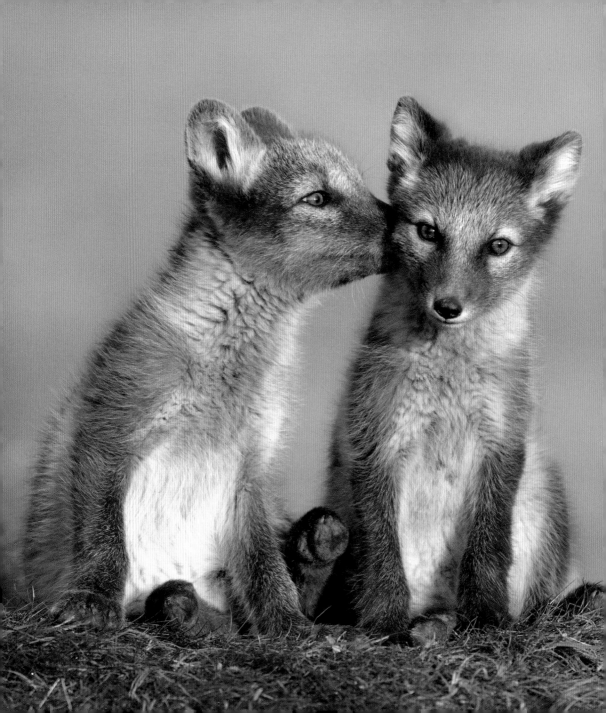

Contents

Introduction

All animal babies, and indeed most living things on earth, share one thing in common – a **life cycle** that starts with birth, continues with growth, progresses to reproduction and ends with death.

However these various **life stages** vary in length dramatically, just like humans, and nowhere is this seen so vividly as in the early years.

In fact, the concept of **'childhood'** itself can range from upwards of ten years if you are an elephant calf or a greater ape such as orang-utan or chimpanzee.

In contrast a baby harp seal is left to fend for itself after just two mere weeks. As for turtle hatchlings, well they actually never even see a parent!

So **welcome to the world** little babies …

For all animal babies, the first few days, weeks and months are about **staying safe**. As different as the babies look, and the habitats in which they live, so too are the survival strategies they use to reach adulthood.

Some species are lucky to have parental protection provided right from the start, other species rely on camouflage to stay out of the sight of potential predators, whilst others climb up high – some reliant on instinct and some under parental guidance. Flamingos and penguins form effective crèche groups – offering safety in numbers – whilst meerkats use the services of a babysitter to look after the young whilst the majority go off hunting.

Now it's time for the offspring to take their **first steps**. For some this comes so naturally – Eider ducklings will swim as soon as they reach water. Others need to stand up and move quickly to avoid danger – including guanacos, zebra and wildebeest – incredibly all within the first hour of life.

As soon as they can move it's vital that babies learn **where to get food**. Herbivores need to chase the rains to guarantee fresh shoots to eat. Cheetah cubs however have to chase live prey! It will take courage and plenty of practice before the young cats become efficient predators themselves. Young chimps eagerly watch adults use tools to crack open nuts – it will take some time to learn but one day they will!

Play is another thing most animal babies have in common. The young of some species have endless energy and enthusiasm for running, chasing, jumping … but it all serves a purpose, that of teaching the fundamental skills required for hunting, mating and ultimately survival. Playing enables young animals to learn about their environment – and see what they can achieve with newly acquired skills!

Particular animal babies, like turtles, are born to be solitary and will only come together for mating purposes, whereas others, such as cheetah brothers, will hugely depend on making alliances and **forming social bonds** whilst young to see them succeed later in life.

Finally it's time for the babies to reach their own particular **rites of passage**. For gyrfalcon chicks it's time to fledge, to jump off the cliff and fly. For mountain goat kids they need to brave the raging river rapids to reach essential minerals the other side. For a grizzly bear cub the goal is to catch its first own fish! The ultimate goal is to become independent.

For all animal babies, it's about **survival** – getting enough food to build up strength, learning how to avoid predators, finding your place in the pack, discovering how to compete with others as well as make useful friends. No matter where they are born or how much parental input is given, the young need to acquire and adapt the skills needed to thrive in their habitat.

All this happens so that they too, one day, will have babies of their own.

Hello World

For some lucky animal babies, such as **Polar bears**, life starts within a cosy den – snuggled up close to their mother, the source of food and protection. By the time the bear cubs emerge they are eager to discover the world of snow and get moving!

In contrast **Turtle** hatchlings come into the world alone – they hatch from eggs buried in the sand, clamber to the surface and immediately are faced with the huge challenge of getting to the relative safety of the sea whilst avoiding all hungry predators.

Some animal babies, such as **Meerkats** and **Wolves** are born into strong family units with lots of protection immediately around them. **Elephant** calves are wobbly to start with, it's hard to find your feet when an excited herd is keen to meet you – but this same herd will help it learn to find food, water and avoid predators on the African plains.

Other animals that spend their adult lives in water come back onto land to have their babies – such as **Giant otters** and **Penguins**. Baby **Fur seals** are born onto noisy, crowded beaches where it's so easy to lose sight of mum. The pups soon realise it's safest to be part of a crèche – a group offers far more protection in such boisterous environments.

For animals continuously on the move, the babies initially get a free ride from willing adults. Mothers have different ways of carrying their babies – a joey in pouch, **Lion** cubs in the mouth, and **Gorillas** on the back.

All animal babies need to learn to survive – and ultimately thrive – in whichever challenging environment they have been born into.

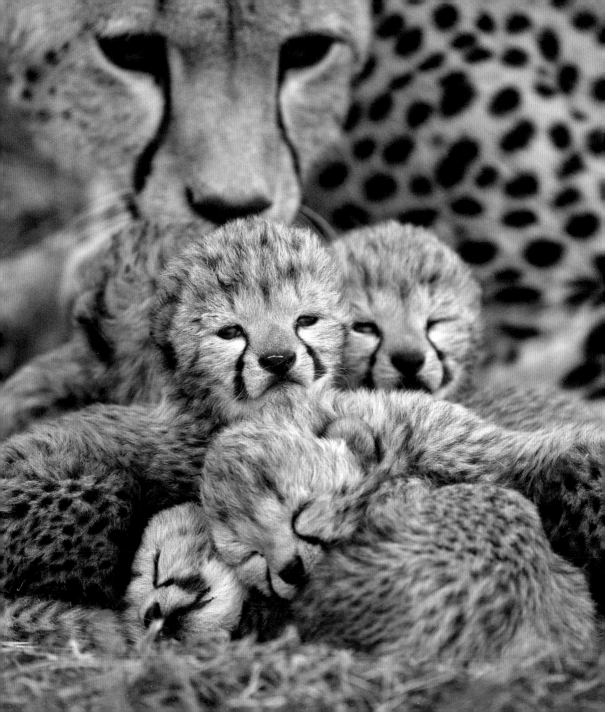

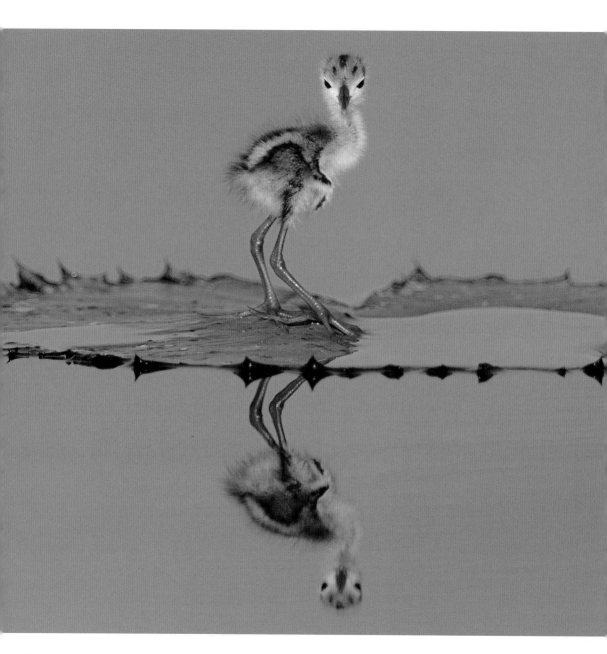

An **African jacana** chick is able to walk very soon after birth – its incredibly long legs and toes mean the body weight is spread over a large area so it can walk across floating vegetation such as this large lily pad. It is very much a waterbird!

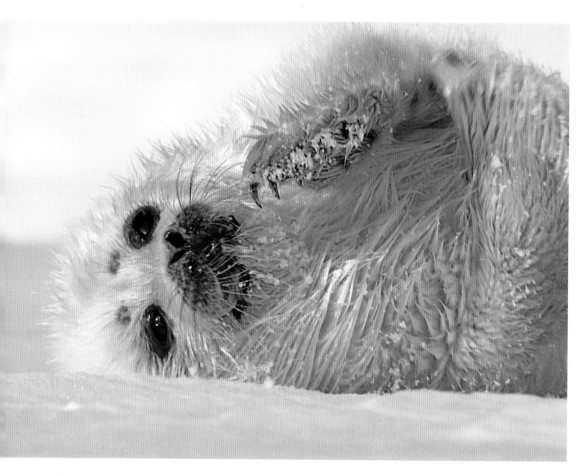

This adorable **Ringed seal** pup is born
with thick white fur to both protect
against the extreme Arctic cold as well
as provide camouflage against the snow.

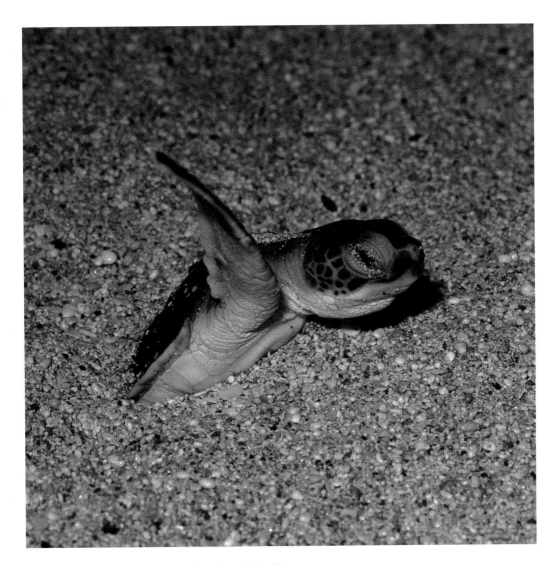

A **Green turtle** hatchling scrambles to the surface using its flippers to move the sand aside. There is no parental protection offered to this baby – the only safety comes from mass hatching but the odds are stacked against them none the less. It's a very tough start for a baby the size of a ping-pong ball.

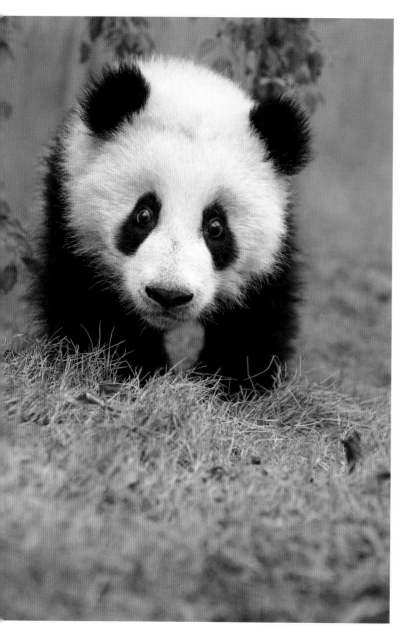

In the wild this **Giant panda bear** would not leave their mother until at least 18 months of age – in fact they would need to be carried on her back for the first 6 months of life and continue to nurse well after they had tried eating bamboo for the first time.

A little **Mountain goat** kid attempts to groom itself once it has come down from the snowy mountains and into greener pastures.

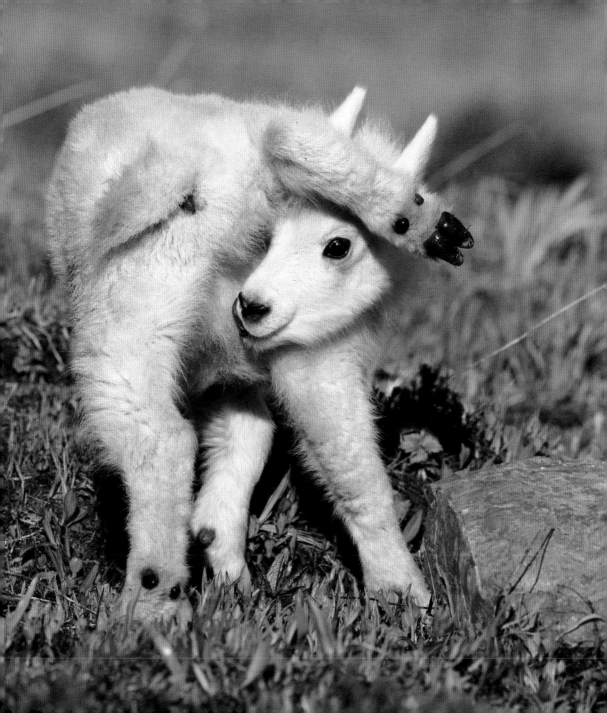

A female **Grizzly bear**, called a sow, will fiercely protect her cub against all threats, including large male bears that pose a real danger. Until recently the cub has fed exclusively from the female, but now in summer meadows it will try solid foods for the first time – whilst sticking close to mum.

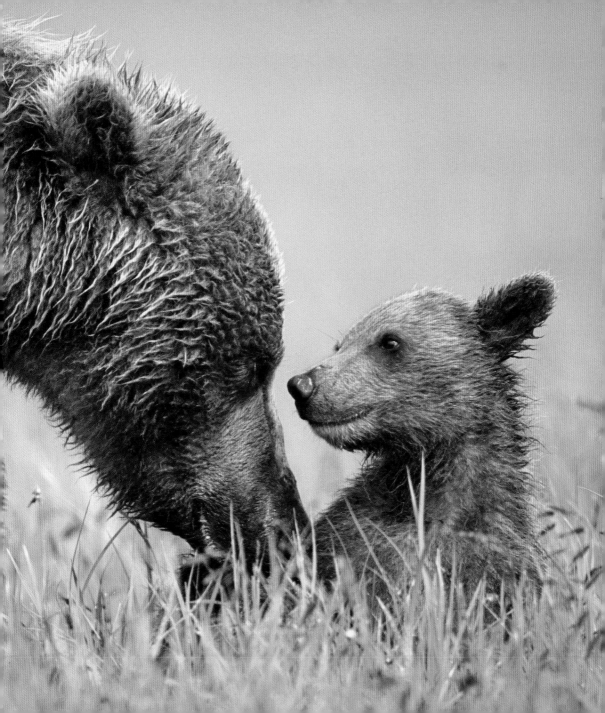

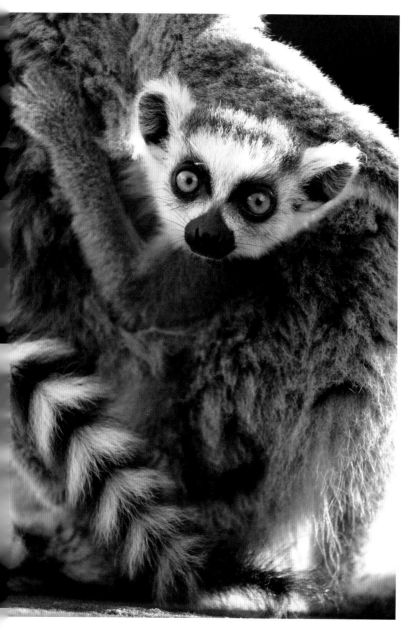

Although a baby **Ring-tailed lemur** will cling to its mother to start with, within a week or so it will start trying solid food and after just a mere month it will start to venture off solo. Incredibly by around six months it will be fully weaned – in other words, this lemur will grow up fast!

The largest of all penguin species, the **Emperor penguin**, has to endure the coldest of habitats – the Antarctic. After hatching this chick is brooded in what is called the guard phase – it spends all of its time either sheltering within the brood pouch or balancing on its parent's feet, as it is here.

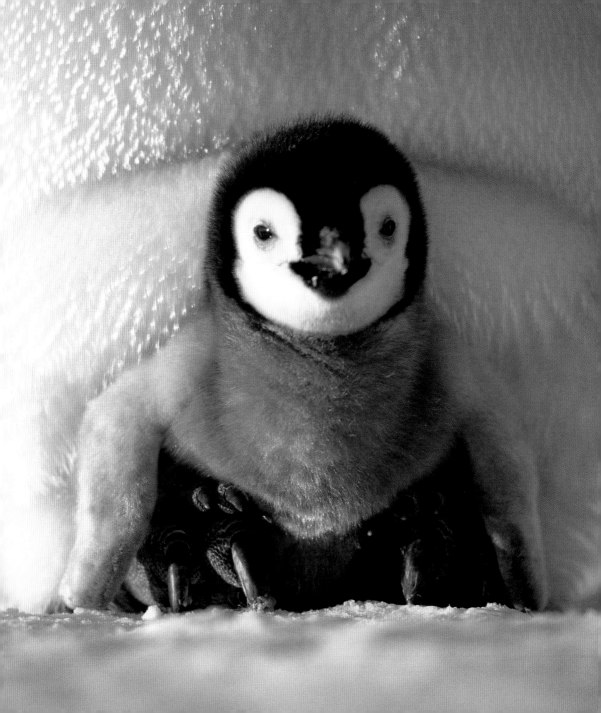

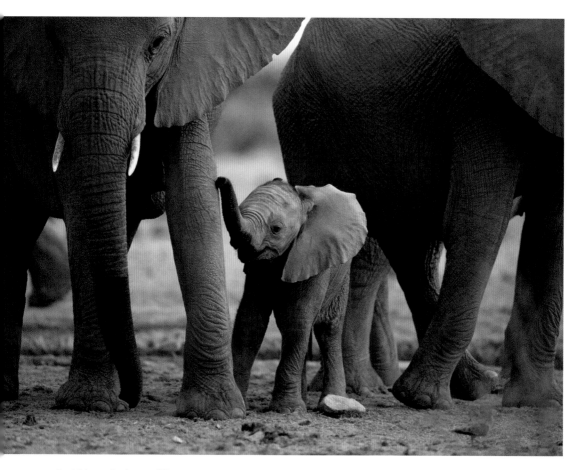

An **African elephant** calf has stumbled to its feet and now is looking for its first milk feed which will provide the nourishment it needs to start taking its first, albeit wobbly, steps.

Polar bears are born blind and helpless but they are also born safe in underground snow dens where they will spend their first few weeks feeding from their mother and getting to know her scent. By the time they emerge they are well fed and ready to explore, whereas mum needs food to replenish her own energy as soon as possible.

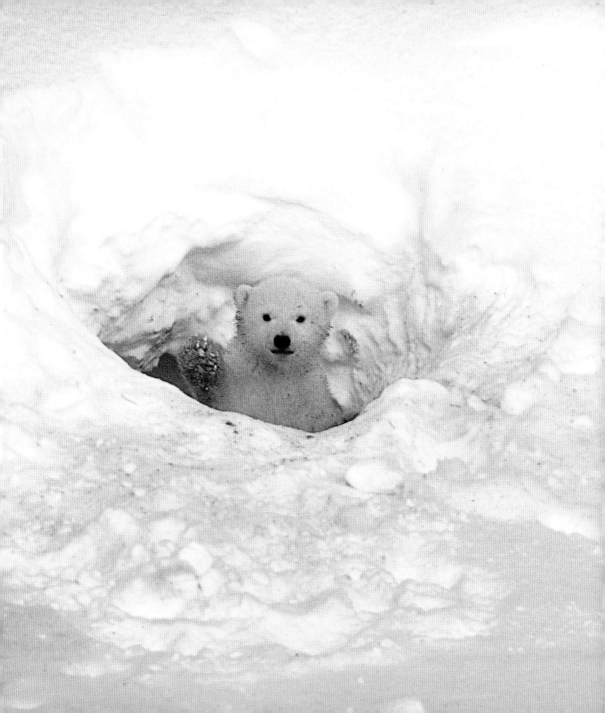

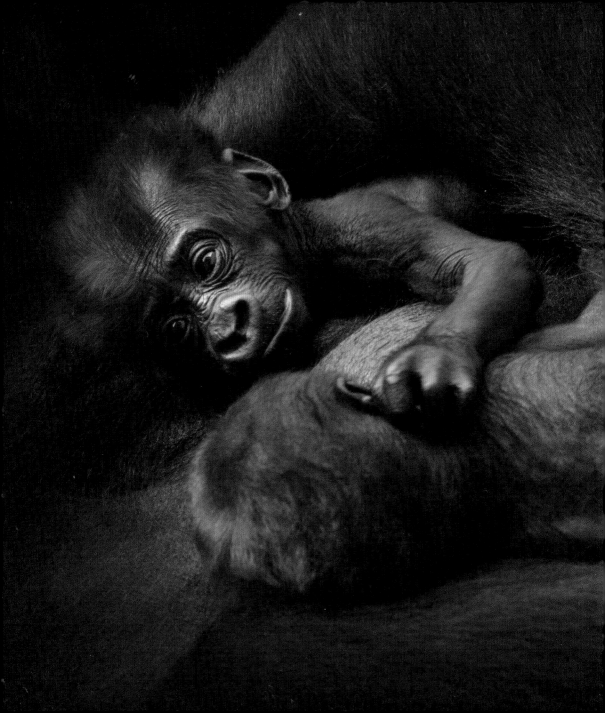

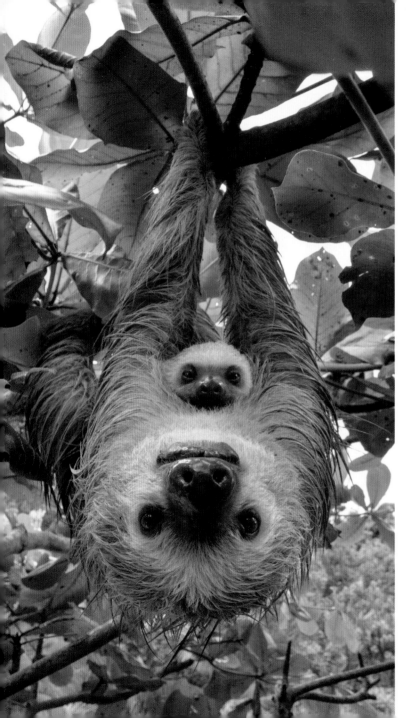

PREVIOUS
An intimate moment of twin
Western lowland gorillas resting
together in their mother's arms –
safe and secure.

This **Hoffman's two-toed sloth**
baby was born with claws that
enabled it to grip onto mum's belly
and remain there for the first few
weeks of life, feeding at will. Most
likely the female will carry her infant
around for the next 6–9 months, first
on her belly, then her back – the safest
way to introduce it to life in the trees.

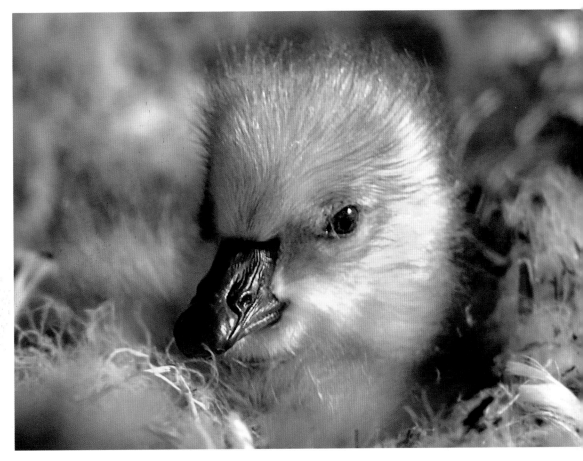

From the moment they hatch **Snow geese** chicks are well adapted to the cold, with a thick layer of down covering their bodies. The goslings grow quickly and within just a few days can swim and feed on their own; however they will remain with their parents for the first winter.

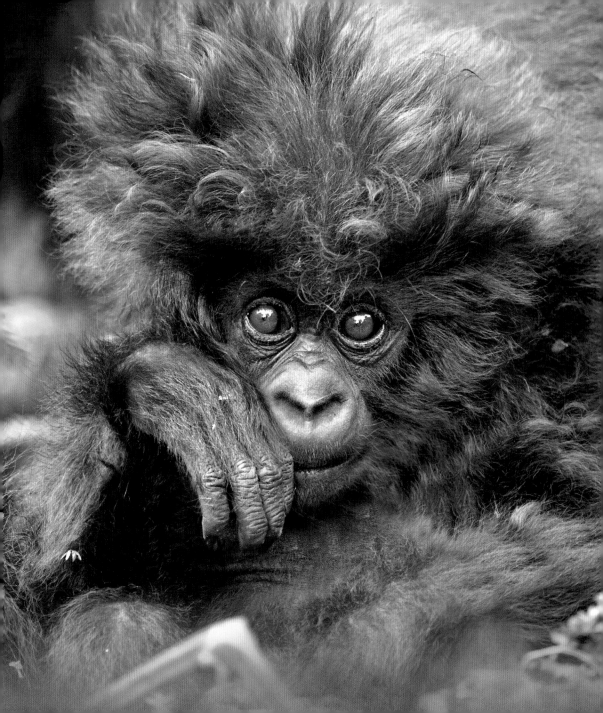

Up until the age of four this **Mountain gorilla** baby can hitch a ride on an adult's back to get around.

This **Lesser flamingo** chick won't be strong enough to stand and walk for at least the first week, so the adult feeds the chick around the clock. As long as the chick remains in the purposely-high nest it will be safe from the caustic mudflats below.

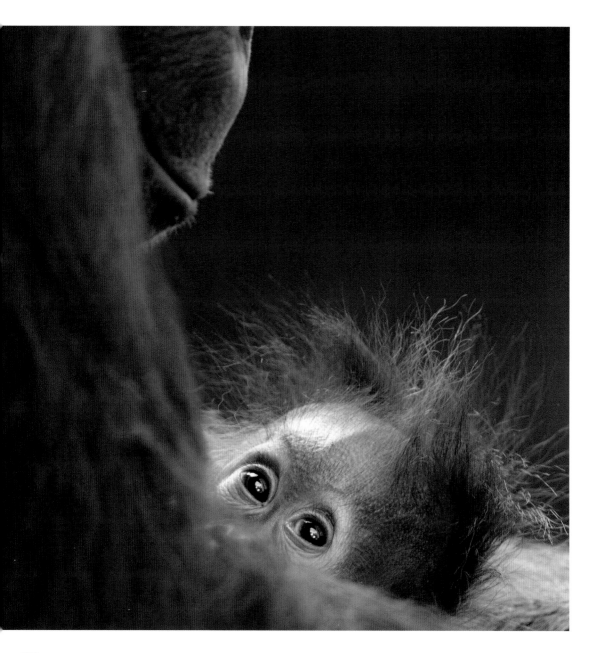

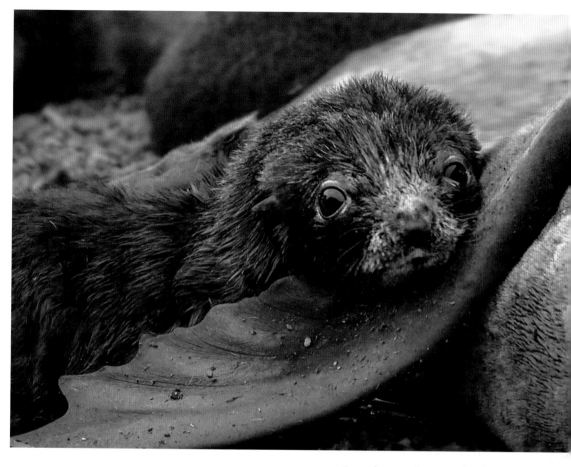

Other than perhaps humans, baby **Orang-utans** have the longest 'childhood' seen in mammals – being carried until five years of age, nursed until they are eight and remaining close to their mother until ten years old – and then even coming back to visit her thereafter!

Fur seal pups are born onto densely crowded beaches and face the real danger of being trampled by large males jostling for territory – it's best to stick close to mum for the first few weeks of life.

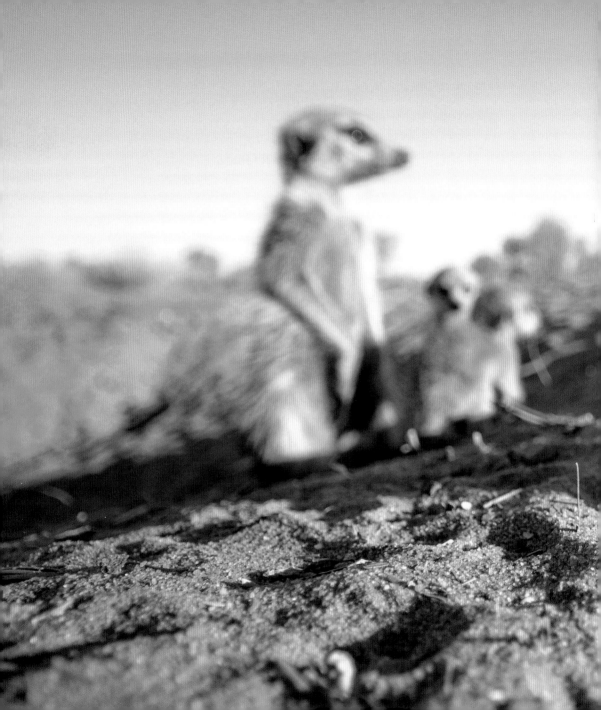

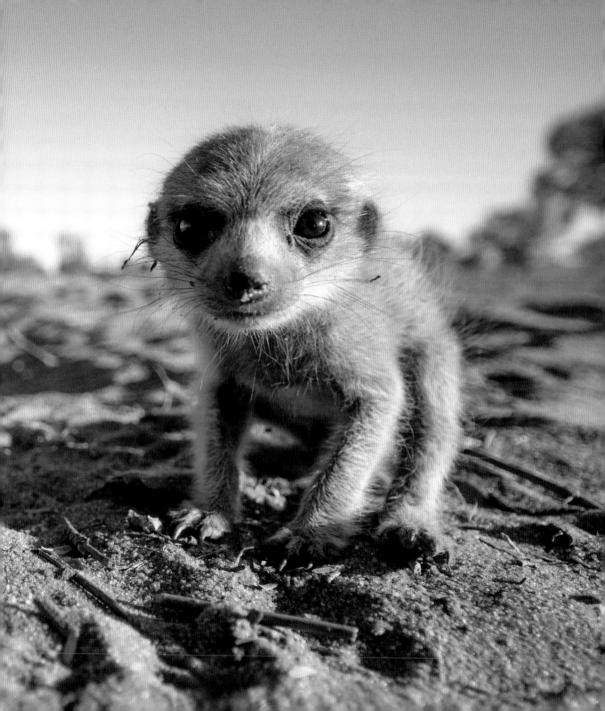

PREVIOUS
At three weeks of age these **Meerkat** pups are sitting outside their burrow for the first time – but they are vulnerable so a babysitter sits nearby keeping a good eye on them.

When first born **Ostrich** chicks have very thin feathers and are consequently at risk of sunburn. So this little chick needs to find shelter under a parent very soon and most likely this will be the father who provides most of the parental care.

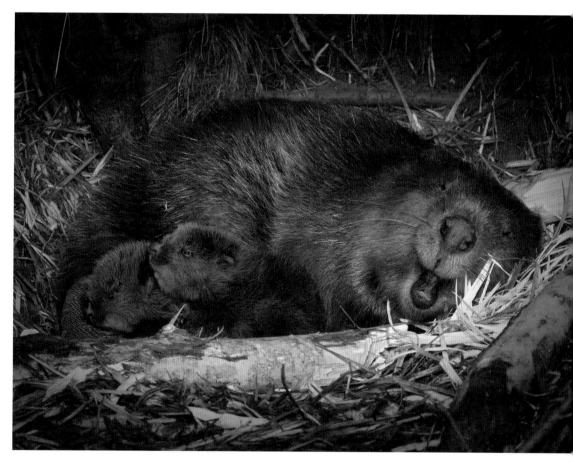

These two **European beaver** kits
are newborns and will remain safe
and cosy in their lodge with their
parents for the first month of life.

Staying Safe

All babies by their very nature are small and vulnerable. Reaching adulthood is by no means guaranteed so they all need to do whatever it takes to stay safe.

Babies born high up in the mountains are safe initially at altitude, but soon they will need to find food, which is scarce up there. Time to find their feet and head down the steep slopes – a daunting first challenge. **Mountain goats** have to be sure-footed on the treacherous slopes – but they are natural born climbers!

Climbing is a means of safety for other babies. From a higher vantage point up in the trees baby **Capuchin monkeys** have a better chance of spotting predators and giving the alarm call. It's never too early to learn to be part of the group and helps everyone's chances of survival.

Another easy way to stay safe is to stay hidden. Lots of young are born with particular features to aid camouflage against their habitat. Coastal bird chicks are mottled to enable them to remain hidden on pebble beaches. **Cheetah** cubs are born with a grey mantle strip of fur to resemble a ferocious honey badger which no lion or hyena would go near!

Other babies use safety in numbers and form crèche groups. Plucky young such as **Penguins** are even brave enough to take on predatory skuas together – it's an important life lesson to put on a united front and learn to stand your ground.

Some family groups need to go out hunting to provide food for the young – so leave them in the care of babysitters. **Survival here will depend on babies learning to keep together – those that sneak off are open to all sorts of danger and far less likely to make it to adulthood.**

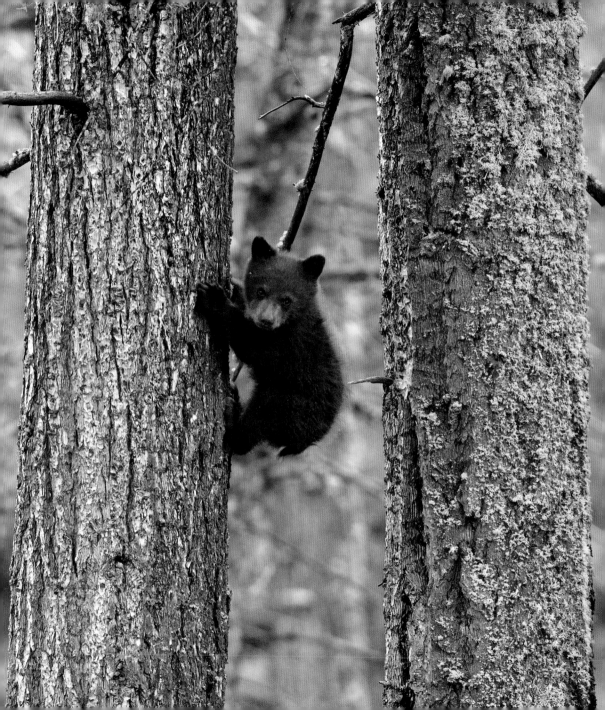

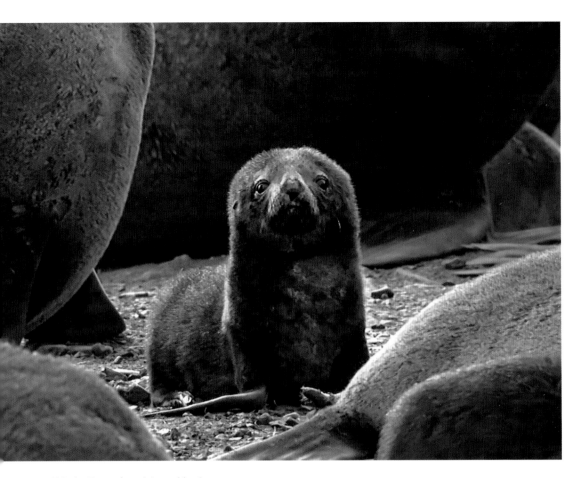

This tiny **Fur seal** pup is in trouble – it is lost in the colony and at risk of being trampled. Being very vulnerable alone, mum needs to listen for the pup's unique call and get back to it as soon as possible!

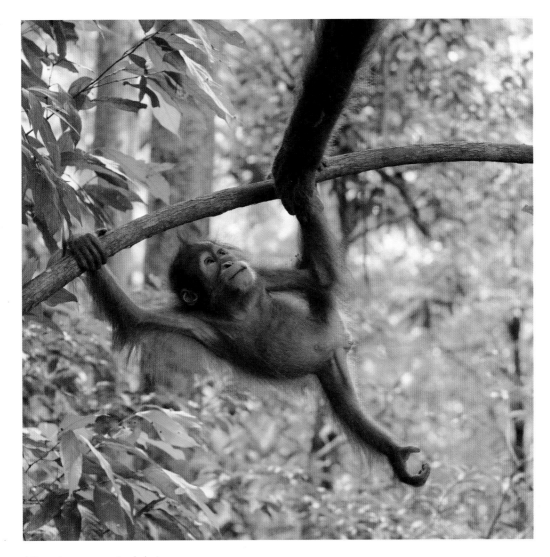

A **Sumatran orang-utan** baby is getting to know its arboreal habitat and learning to climb and swing, safe in the knowledge that its mother is always nearby to lend a hand.

These little **Caribbean flamingo** chicks will lose their juvenile pale colour gradually over a couple of years and gain their striking pink plumage. For now, as they gather in a nursery crèche, they are under the careful watch of adults.

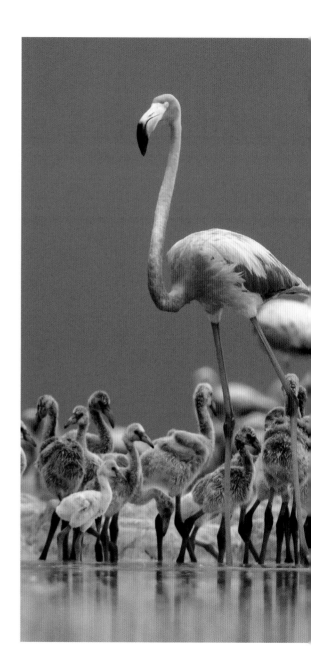

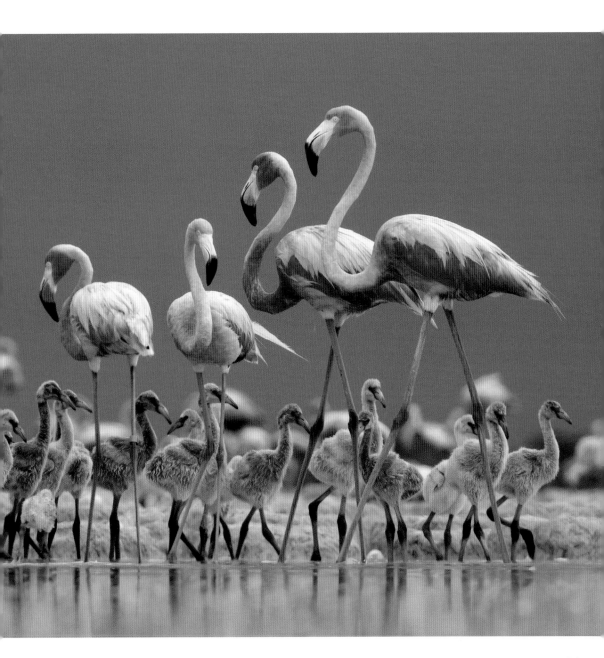

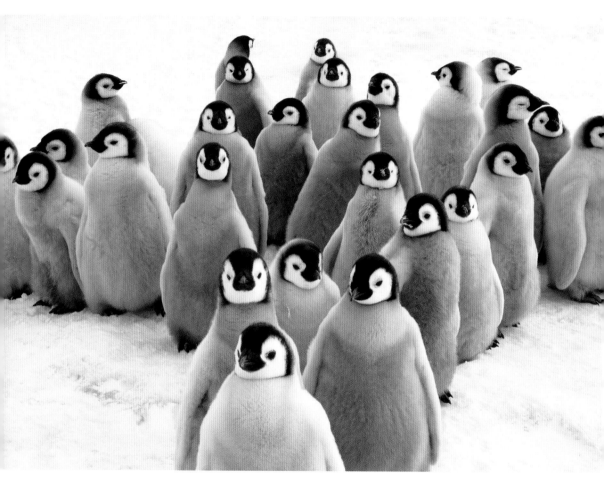

When they reach around two months of age **Emperor penguin** chicks form crèches and these provide security in a number of ways. In the cold the chicks can form a tight huddle for warmth, their many eyes can be on alert for opportunistic predators such as skuas – and indeed if they stand united can actually deter such threats. Most definitely safety in numbers!

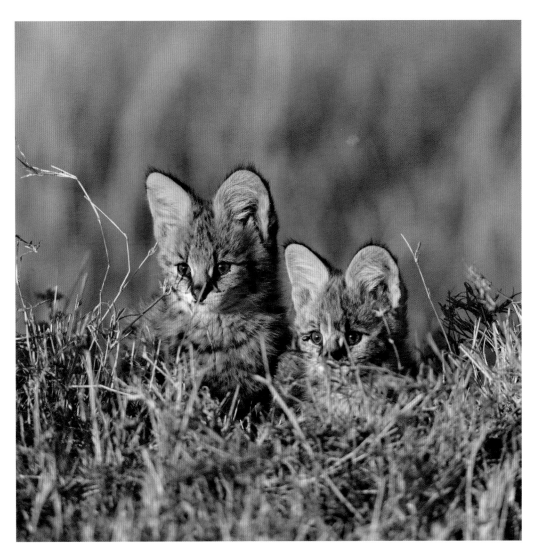

For some animal babies a good way to stay safe is to blend into your surroundings. These two **Serval** kittens have fur markings that provide camouflage against the grassland habitat and as long as they lay low they have a good chance of going unnoticed.

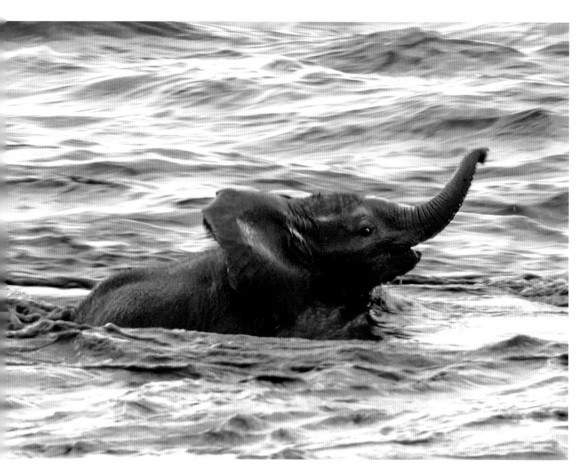

A little **African elephant** calf is struggling to cross a raging river – and has become separated from its herd. This is a really dangerous situation for the naïve baby and it needs help urgently.

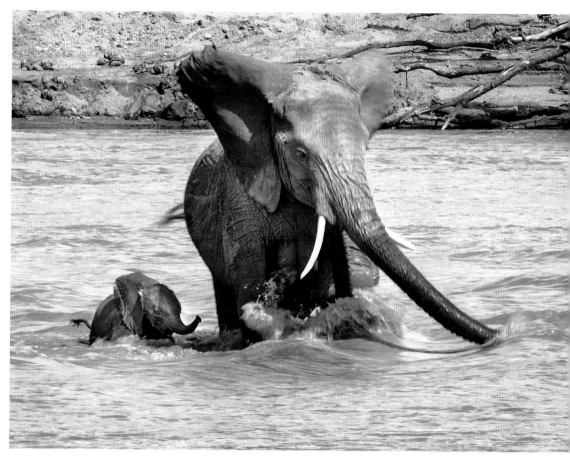

Thankfully an experienced female **African elephant** is now leading the calf across a calmer, shallower stretch of river and using her body to shield the baby from the strong currents. Knowing where and when to cross rivers is just one of life's lessons that the matriarch will pass down to younger generations of elephants.

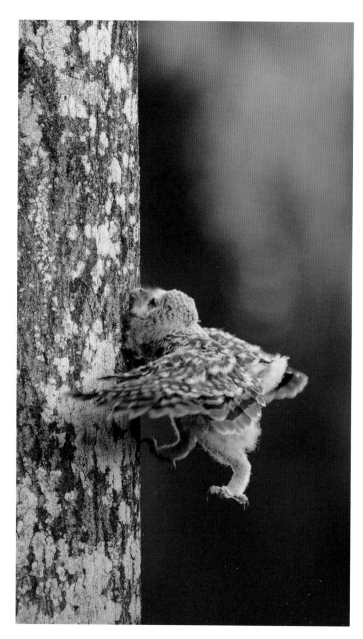

This **Ural owl** chick probably fell out of its nest before it had learnt to fly – so it's desperately trying to climb back up to safety using its beak, talons and wings.

OVERLEAF
This female **Grizzly bear** did not eat all winter whilst she hibernated and nursed her new cub – now she must regain her weight before next winter. The cub too must eat sufficiently before the snow returns, to stand the best chance of surviving the winter – but for now it is more interested in hitching a ride and having fun.

Meerkat pups are born into a tight-knit society and will seek reassurance and protection from many older members of the tribe, not just parents. Once they venture out of the burrow they will spend the first part of the day sunning themselves to warm up.

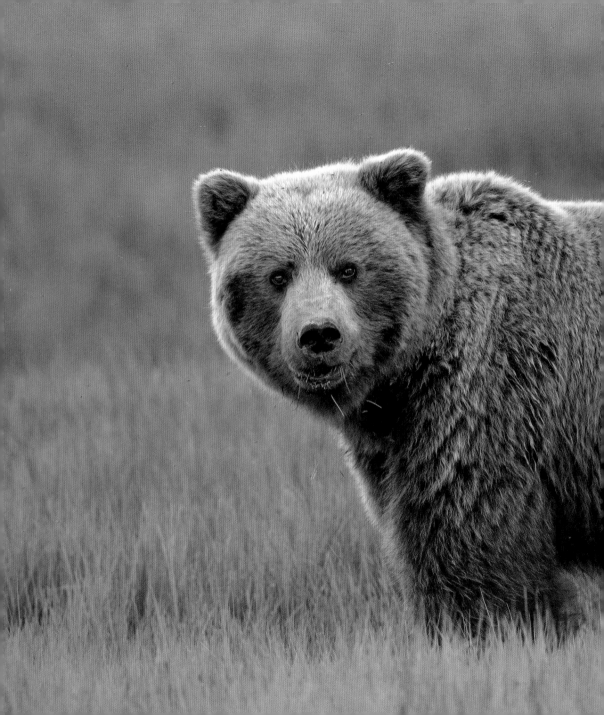

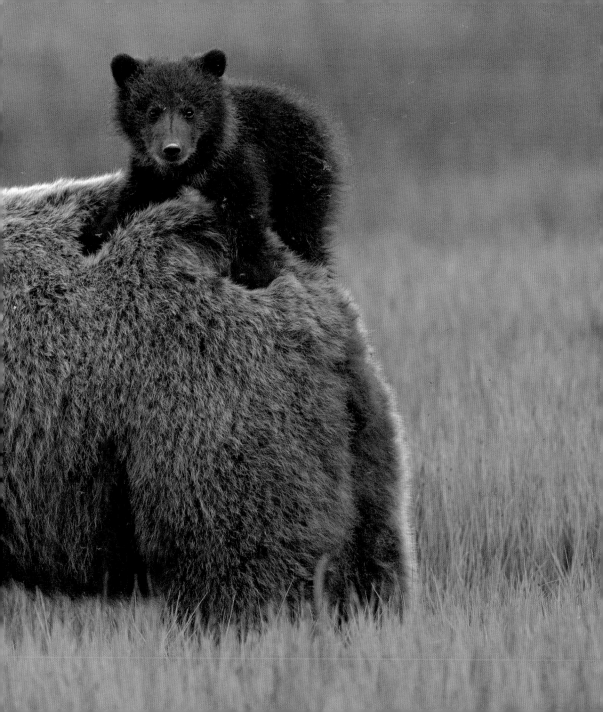

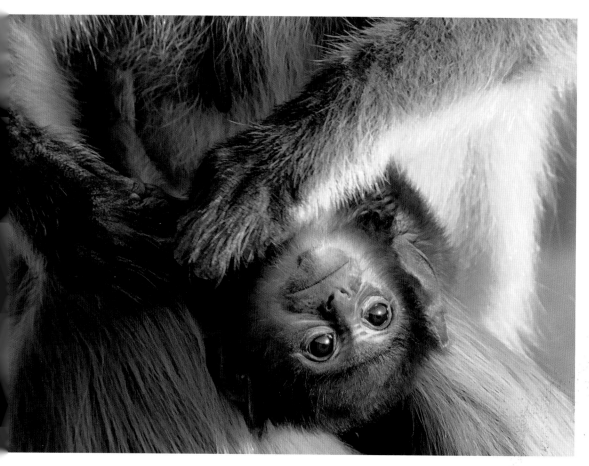

Young primates such as this **Hanuman langur** see most of the world upside down as they cling tight to mum in the first few weeks. As they grow older and stronger some species will move to riding on her back, again offering a wonderful view of everything around – there is so much to see and learn about!

Initially born on land with white fur for camouflage against the snow, within three weeks this **Harp seal** pup's coat will have completely moulted to silver with dark spots. By then it will have to be swimming and catching its own food, fast adapting to an almost exclusively aquatic lifestyle.

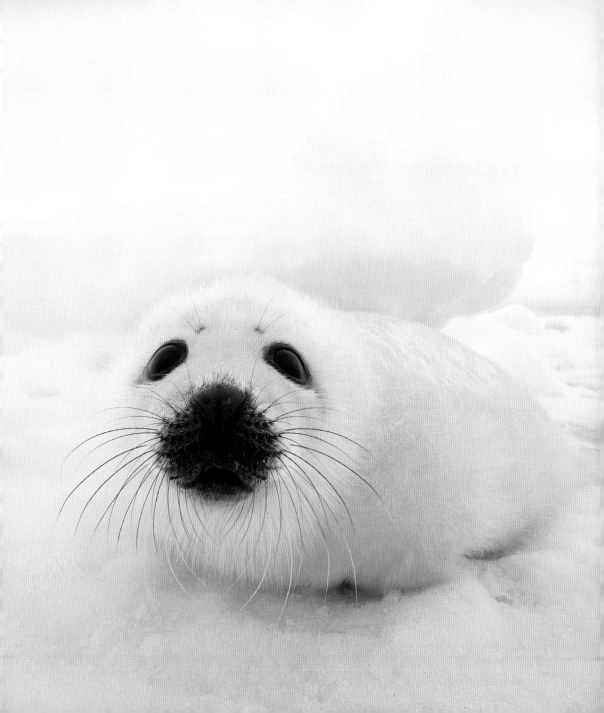

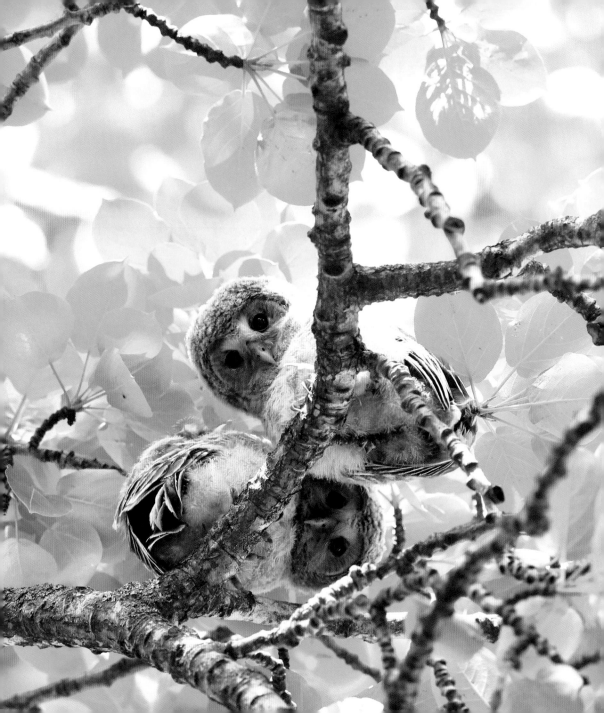

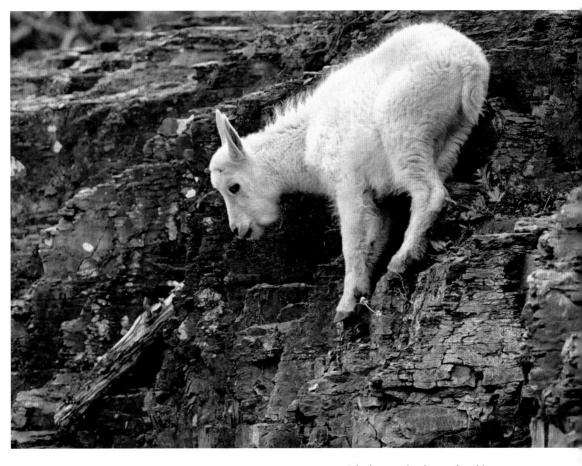

It looks precariously steep but this **Mountain goat** kid was born a natural climber and will confidently follow the adults down to the summer feeding grounds. It has hooves that can splay out or squeeze depending on whether it needs to stop suddenly or grasp irregular shaped rocks as it makes its way up or down the slopes.

Two **Ural owl** chicks peer down from the canopy. They might not be old enough to fly yet but they are able to hop around on the small branches and get to know their forest home.

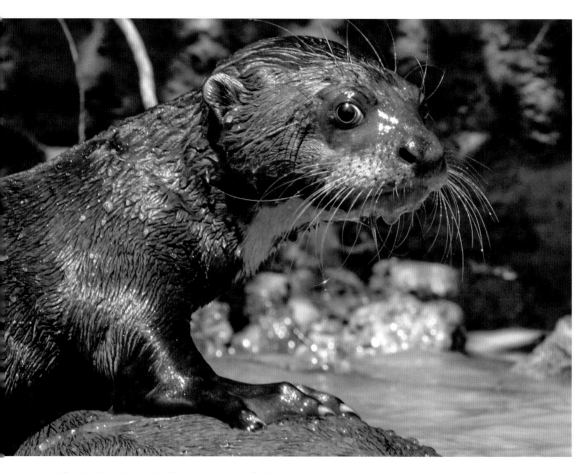

There's a lot to learn other than just swimming for this **Giant otter** pup. Not only does the pup have to learn how to catch fish in the murky waters, but also how to avoid the huge caiman that live there, as well as jaguars that patrol the banks. It's a good idea to stay wary …

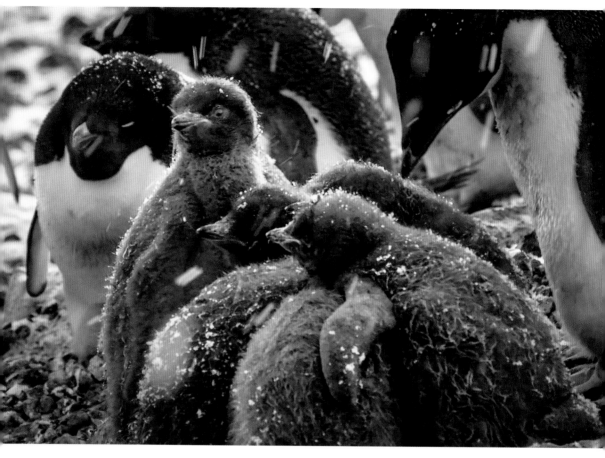

As the weather takes a turn for the worse, these
Adelie penguin chicks group together for warmth.
Although their down feathers provide excellent insulation,
by huddling up together all the chicks conserve precious
energy during extreme cold conditions, whilst their
parents are feeding at sea.

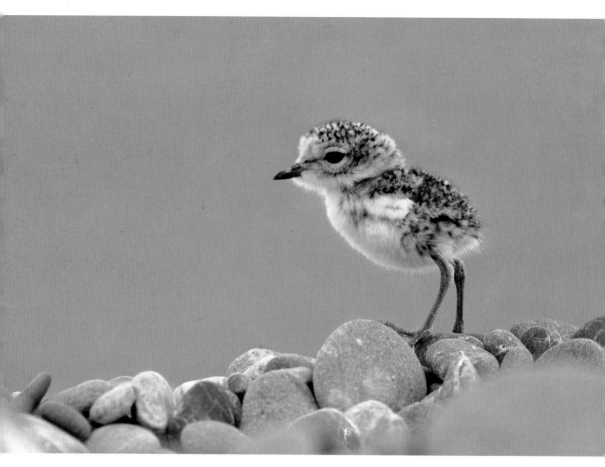

From down low this tiny **Double-banded plover** chick looks very vulnerable and exposed. However from above its mottled feathers provide fantastic camouflage against the pebbles, keeping the chick hidden from the probing eyes of hungry predators. Indeed the egg from which it hatched looked just like another stone on the beach.

Almost as soon as **European brown bears** learn to walk, they also discover trees and start to clamber and climb. Although climbing trees is obvious fun exploration for a cub, it is also a vital way to stay out of harm's way.

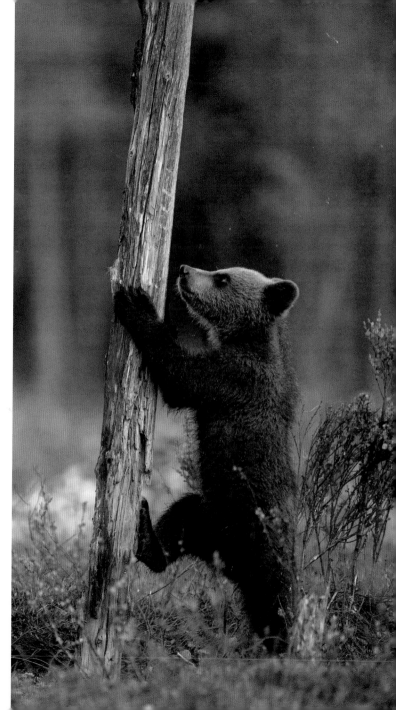

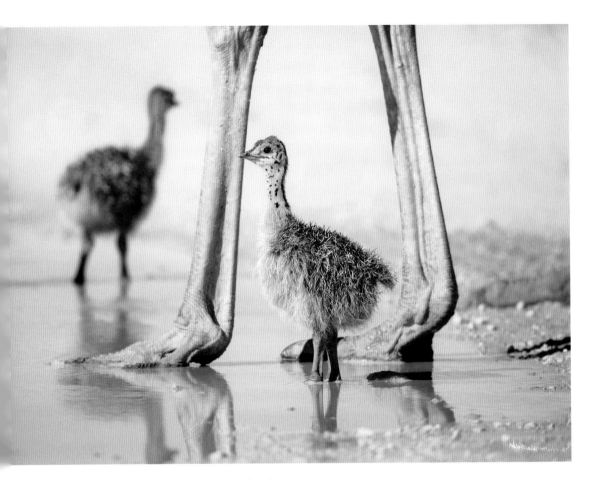

Ostrich chicks keep close to adults not only for safety reasons but because there is also the risk of sunburn so they need to keep in the shade whilst their feathers become thicker. It is obvious this chick has a lot of growing to do to reach the tall height of its parent!

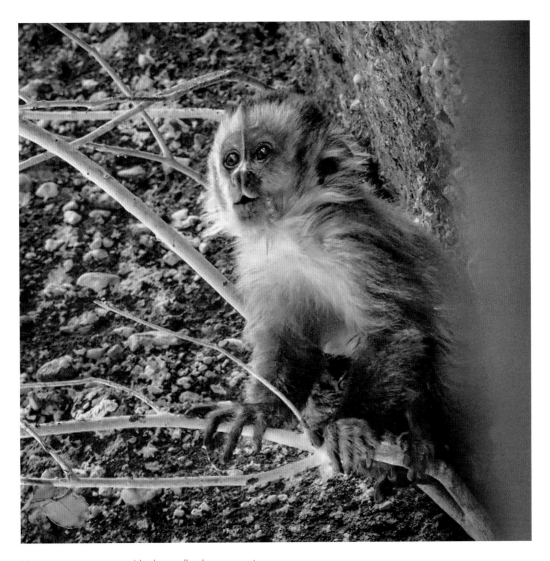

It's never too young to provide alarm calls when you spot danger! A young **Capuchin** has spotted a snake and is calling out to bring its mother back to its side; the call will also serve to warn the other monkeys nearby.

First Steps

Some baby animals need to master movement almost immediately. Within an hour a **Wildebeest** calf is up, keeping pace with its mother and moving with a herd of hundreds of thousands.

Other animal babies need time to grow as well as learn the skills involved before they can move. A few lucky babies can hitch a ride initially, such as baby **Banded mongooses** who are carried between various den sites for the first few weeks of their life – a much easier start.

But sooner or later they all need to move by themselves – it will enable them to find food, keep up with their family, stay safe and ultimately survive. They need to learn to crawl, walk, run, hop, swim or fly.

Certain animals, like **Elephant** calves, start with a few wobbly steps – it can take time to find your balance. Some individuals get the hang of it quickly whilst others will inevitably struggle. **Eider ducklings** have an innate sense of how to swim as soon as their little feet get them to water. **Wood ducklings** however need to be really brave, take that first step by jumping out of their tree nest and 'fly' down to the ground.

Giant river otters experience daunting first swimming lessons – it's sink or swim time but before long it's second nature. **Turtle** hatchlings are clumsy on the beach, flapping their flippers to reach the sea and escape predators – but once beneath the waves they are fast and graceful, born to swim.

Taking their first steps may be daunting but it's a whole new world once the animal babies have learnt how to move.

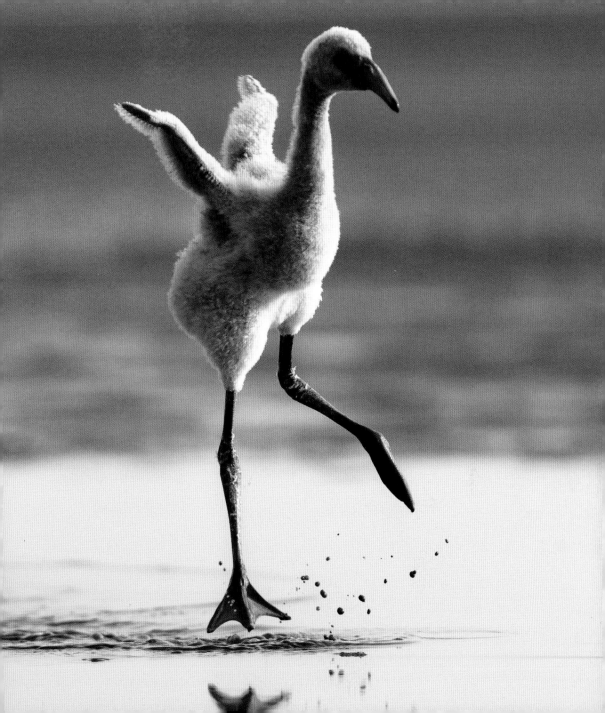

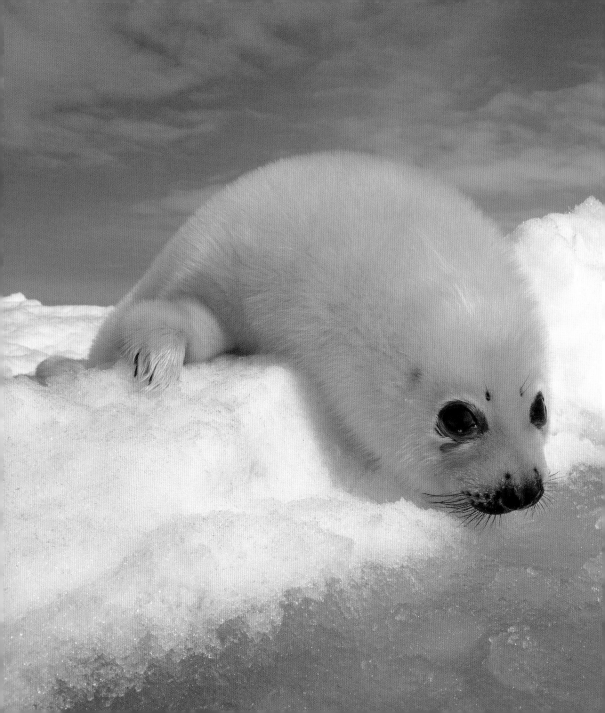

It's a harsh start for this little **Harp seal** pup. It will only be nursed for a couple of weeks then abandoned – so it has to learn to swim, find food and look after itself very soon in life and all before the ice melts!

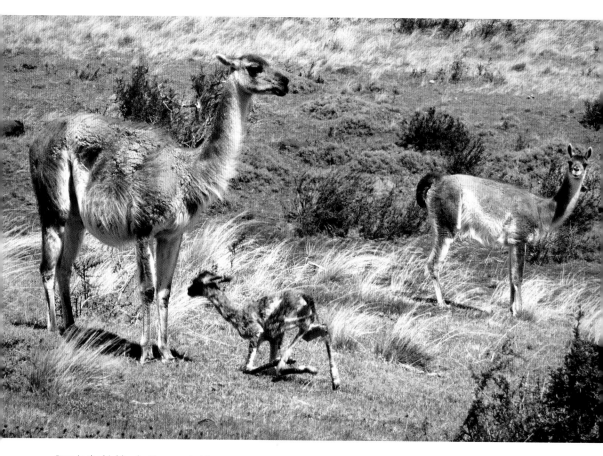

Born in the highlands, **Guanaco** babies
need to overcome the initial wobbles and
stand up, possibly aided by their parent.

Almost as soon as **Mountain gorilla** babies have learnt to walk, they also discover trees – up they climb and the fun really starts!

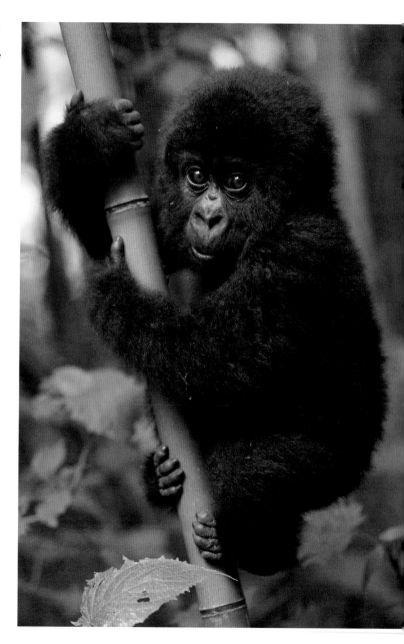

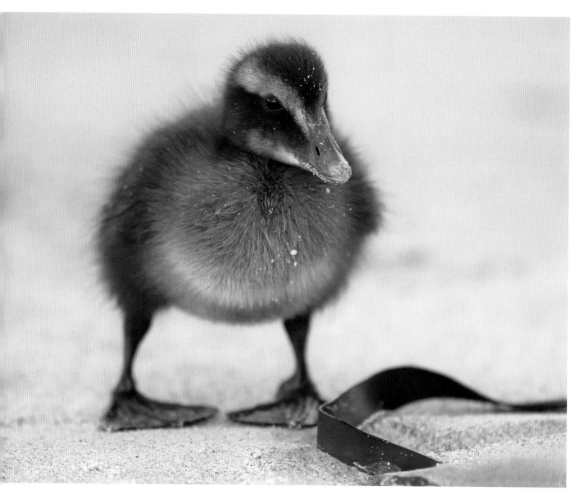

To avoid land predators this little
Eider duckling will have to follow
its parent to water as quickly as
it's little legs will go!

This little **Roe deer** fawn is up and
running – and the more it moves, the
stronger it will become, thus standing
a better chance of outrunning potential
predators, although for the first few
weeks it will spend a lot of the day
hidden in vegetation.

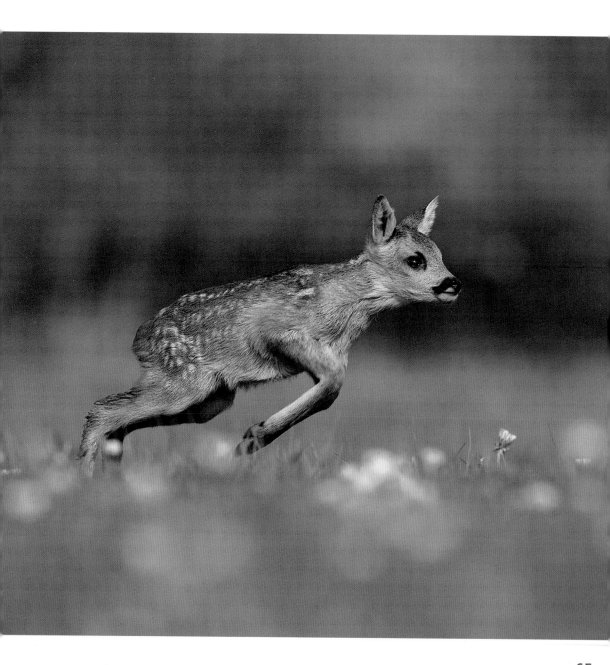

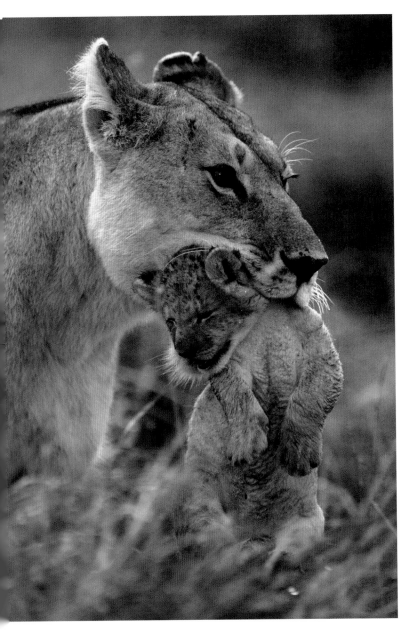

A tiny **Lion** cub won't be able to travel far for the first couple of months so its mother gently holds it inbetween her jaws and moves her vulnerable cub between various den sites to avoid predators.

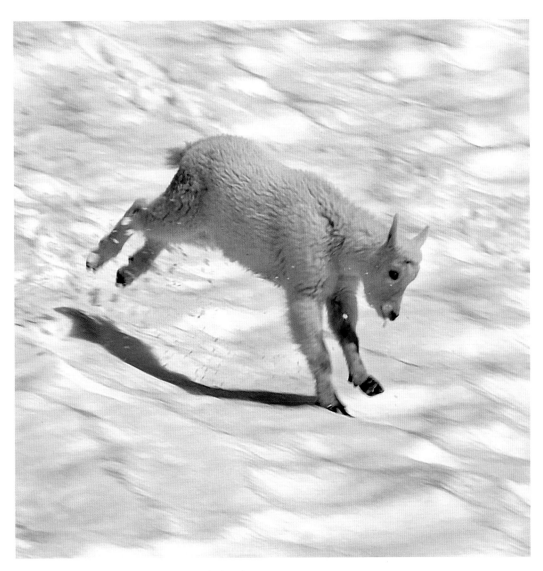

Mountain goat kids are born into a harsh high altitude habitat – but its thick white coat offers both protection from the cold and camouflage against the snow. It even has textured foot pads that give extra grip on the icy slopes!

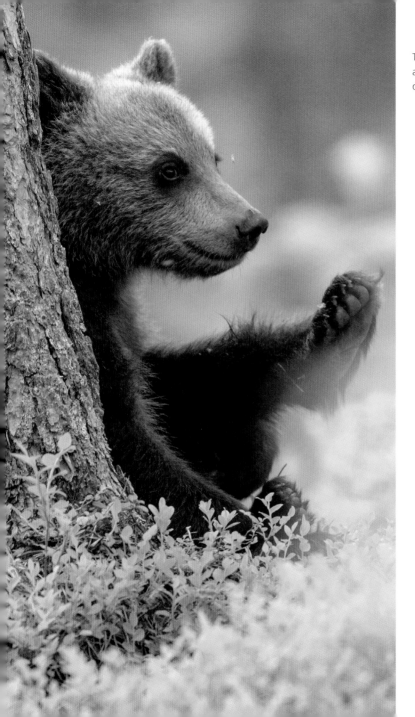

This baby **Grizzly bear** is rubbing against a tree as it has seen its mum do – it feels good!

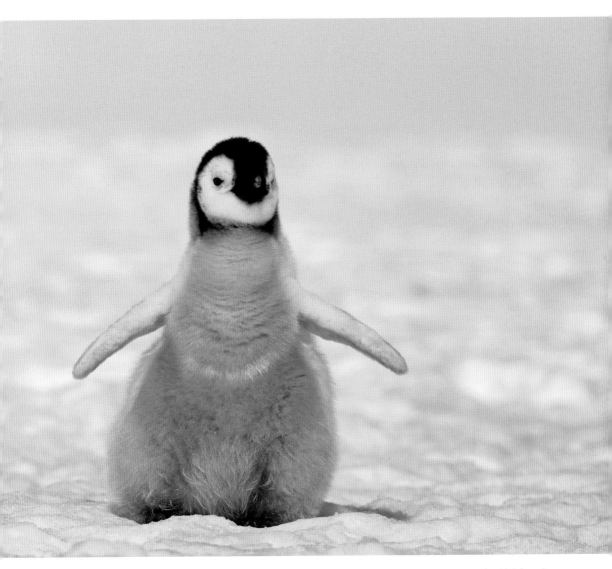

When it was first born this **Emperor penguin** chick found shelter from the extreme cold climate on its parents' feet and within a breeding pouch – but now it's larger it can take its first steps on the sea ice, slippery and cold as it might be!

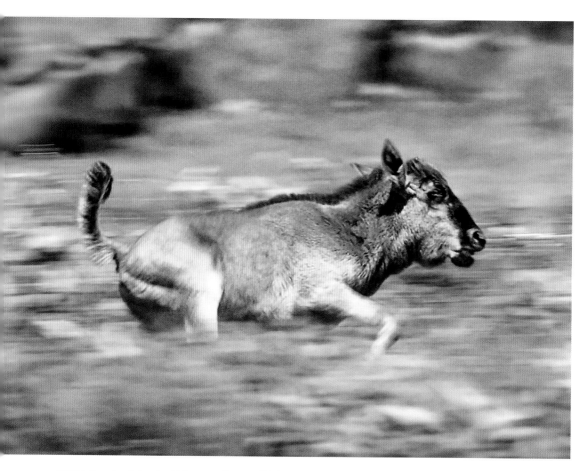

A **Wildebeest** calf stands within mere minutes of birth –
and incredibly starts to run around within an hour. With
every stride the calf gets stronger, increasing its chances of
outrunning predators and, as such, surviving its first year.

Protected by family members, this little **Banded mongoose** is safely carried to a new den site every couple of days – all whilst having a nap!

OVERLEAF
Young **Lesser flamingo** chicks gather together in nursery crèche groups and are led to feeding grounds by an adult or two. Amazingly even in these groups of over 25,000 individuals a parent can locate their own chick by its unique call.

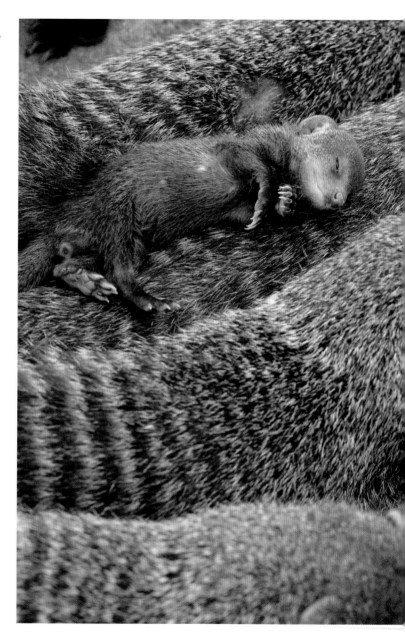

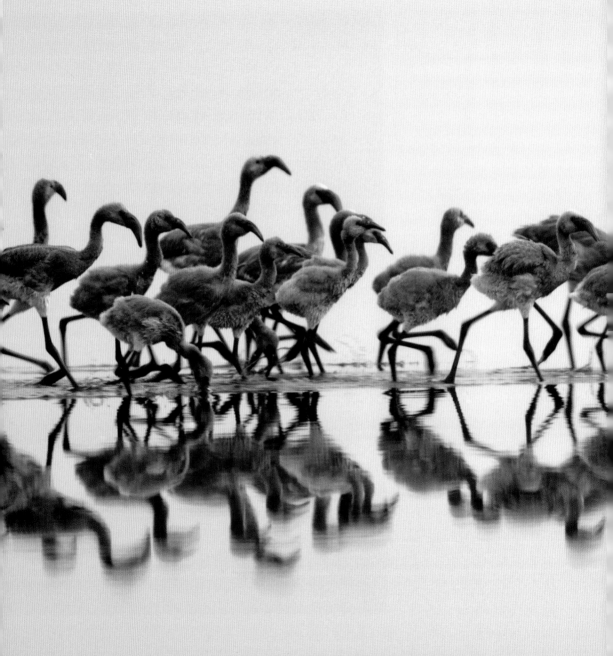

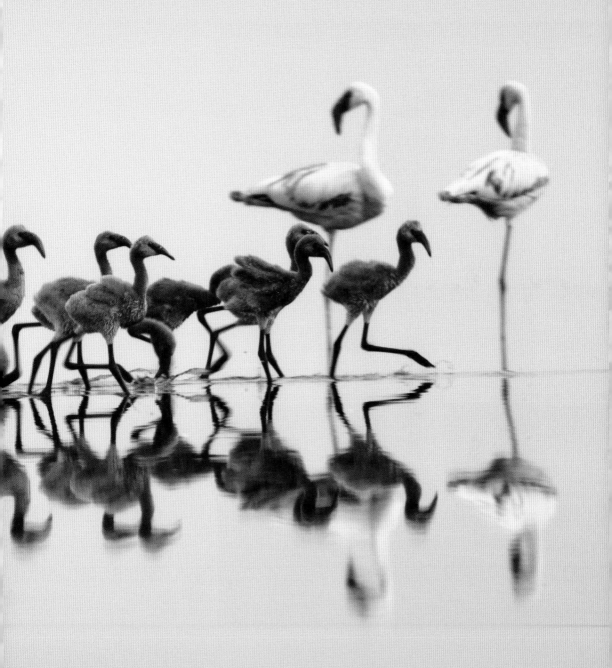

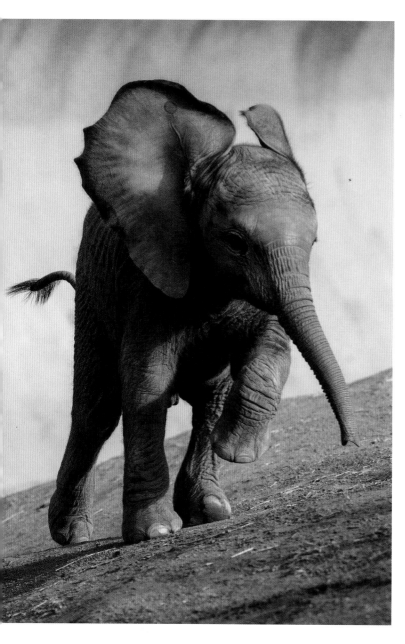

It can be tricky learning to stand on your own feet – but this little **African elephant** calf will have its family around to help if needs be.

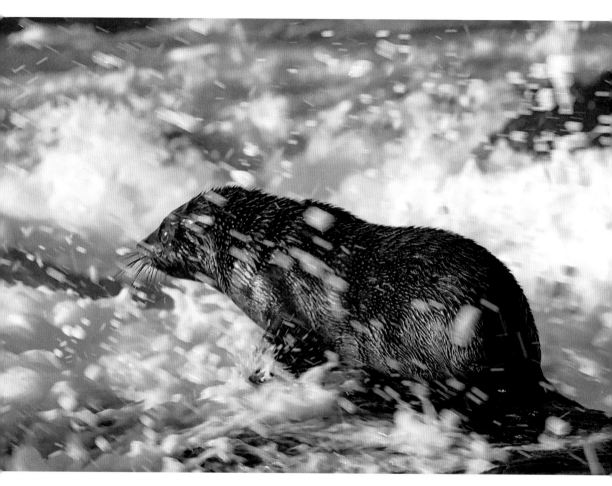

Fur seal pups tend to avoid the sea for
the first couple of months – prior to this
there is great risk of being washed out
to sea by strong waves for those ultra
curious individuals. Better to learn the
skills of swimming in inland 'nursery'
pools before venturing further …

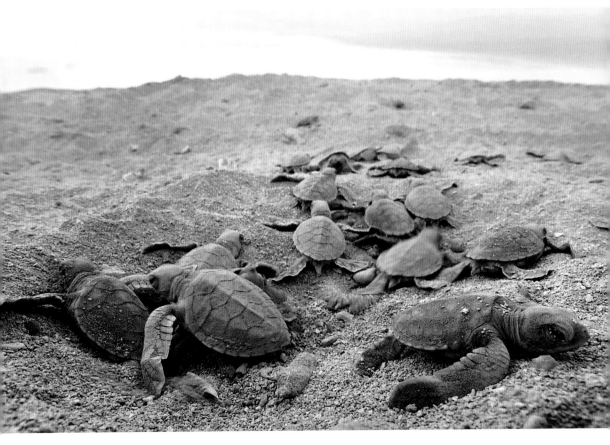

Green turtles are born with no parental protection – instead it's safety in numbers as they clamber to the surface and then scramble to the sea hoping to avoid the myriad of waiting predators.

These **Wood ducklings** are born in a nest, high up in a tree trunk. Their first steps involve leaping out of the tree, falling to the ground and then making their way to water as quickly as their little legs will take them.

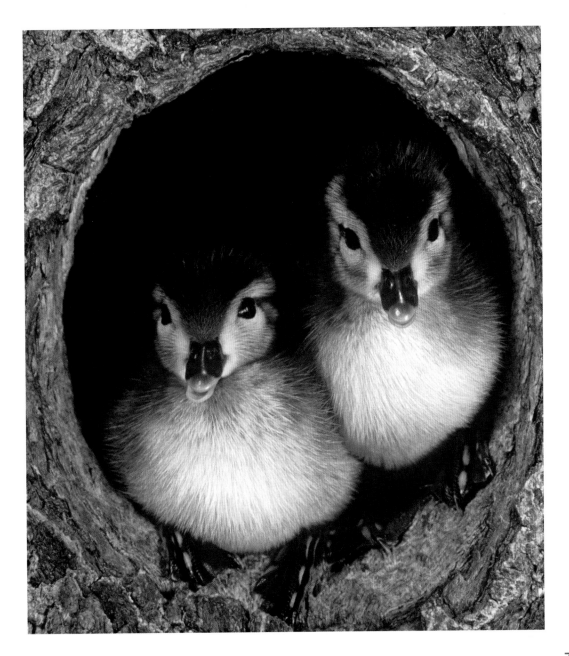

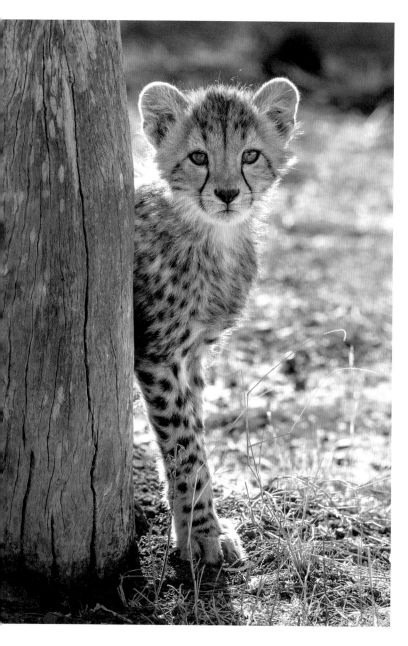

Cheetah cubs have to constantly be on the watch for predators – you have to stay alert to survive on the open plains.

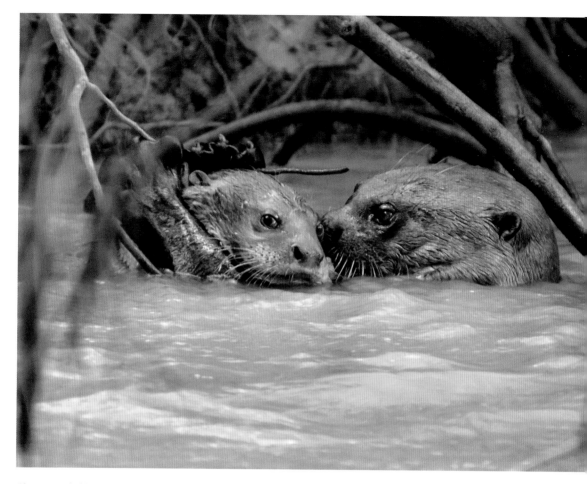

Giant otter babies are born in the dry season when water levels are low and fish are plentiful. However within weeks it's time for their first swimming lesson – it will be a race to become confident in the water before the rains return and the river levels rise dramatically and fishing becomes far more difficult.

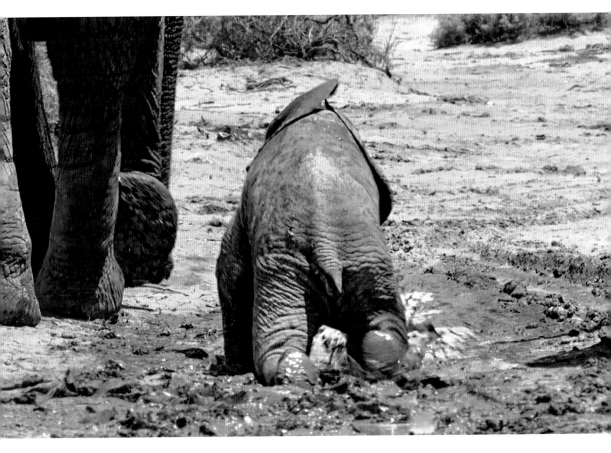

It's hard enough trying to master four shaky legs but this little **African elephant** calf also faces the challenge of slippery mud to overcome as it attempts to keep up with the herd!

This **Green turtle** hatchling has reached the relative safety of the sea. Now the initial clumsy flapping steps across the beach will transform into effortless and graceful swimming beneath the waves – its true home.

OVERLEAF
Arctic foxes can have the largest litter of all carnivores – up to 25 cubs! Now out of their underground den, the cubs survey their surroundings and it won't be long before they start to explore …

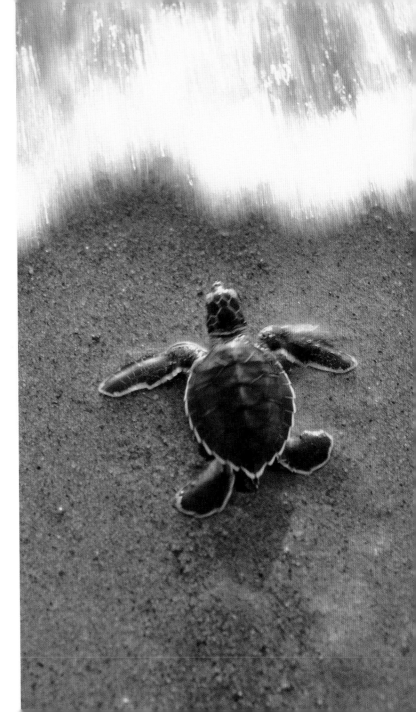

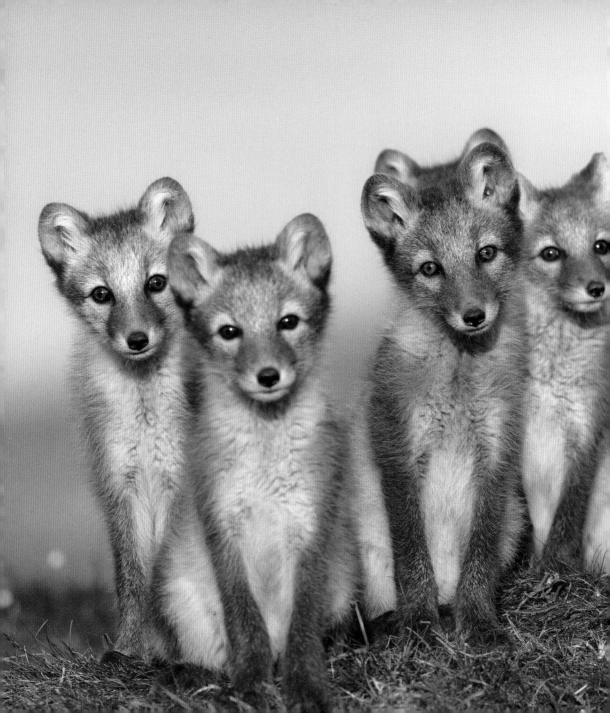

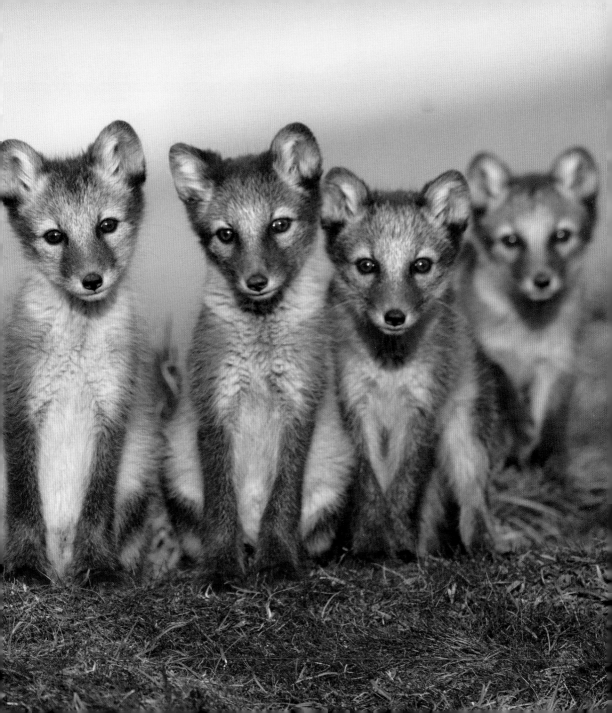

Lunchtime

At the start many animal babies completely rely on mother's milk but the next step, and an important one on the road to independence, is learning to feed themselves.

Herbivores must continually look for fresh grazing grounds – so on the plains of Africa the animals must follow the rains and these babies soon become part of one of the largest migrations in the world. However such epic journeys often include tricky obstacles such as crossing dangerous rivers that stand in the way of the new shoots of grass.

Carnivores have a completely different challenge: catching moving prey. For baby **Meerkats** this task is aided by each young being allocated a mentor to help them identify dinner and show how to dispatch even the trickiest of meals, a deadly scorpion.

Primate babies such as **Capuchins** and **Chimpanzees** will learn sophisticated ways of eating with tools – and all done by watching and copying the adults in their family groups. It will take time to master how to find the perfect stick for fishing termites out of the ground but those young that persevere will be the ones that ultimately thrive.

Some birds have specialist beaks that they have to 'grow into'. **Flamingo** chicks travel to adult feeding grounds in large crèches and there will practise using their now-curved bills until they become adept in sieving the water for food.

However not all feeding is difficult and a cuckoo is the ultimate lazy parent. It lays its egg in the nest of another species such as the **African drongo**. Once hatched the baby **Cuckoo** pushes out all other eggs from the nest, thus removing all competition and gaining all the food. Sneaky but effective.

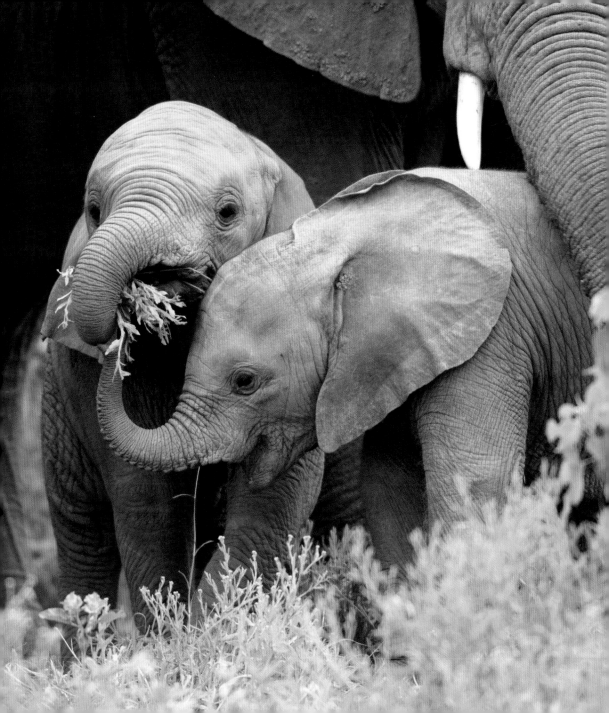

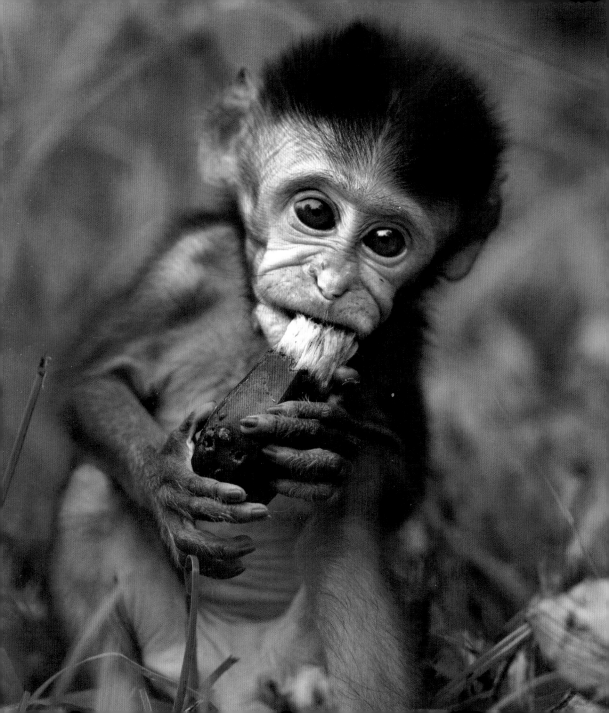

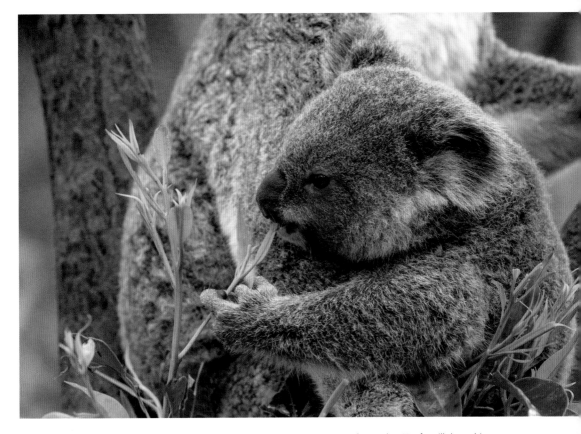

The mother **Koala** will show this young joey which eucalyptus leaves are best to eat. It also has to ingest something called pap from mum – this pap contains the bacteria needed to digest the otherwise poisonous eucalyptus. It's a strange choice of diet!

A **Long-tailed macaque** baby is trying out a screw pine fruit. Fruit will make up the majority of its diet although it will be nursed by its mother for a couple of months before being fully weaned.

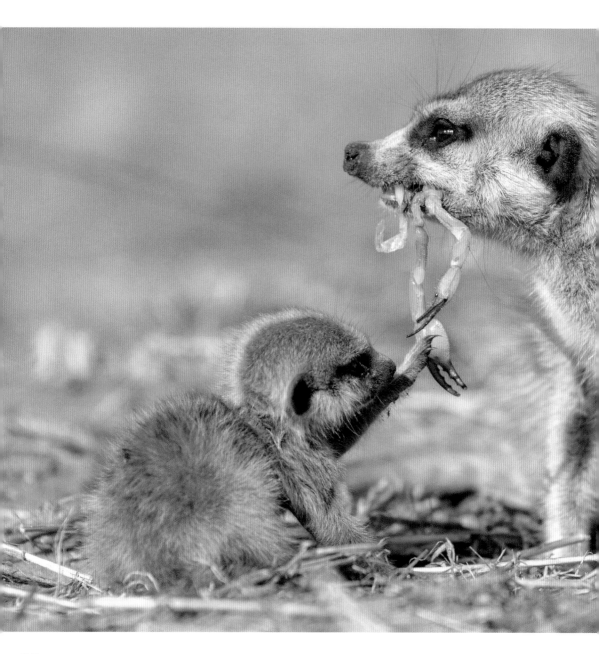

A young **Meerkat** will be assigned a mentor adult who will devote time to demonstrating what is good to eat, how to catch it and – in the case of the scorpion here – how to disable the poisonous sting. Over time the young pup will master all these skills and become an efficient hunter.

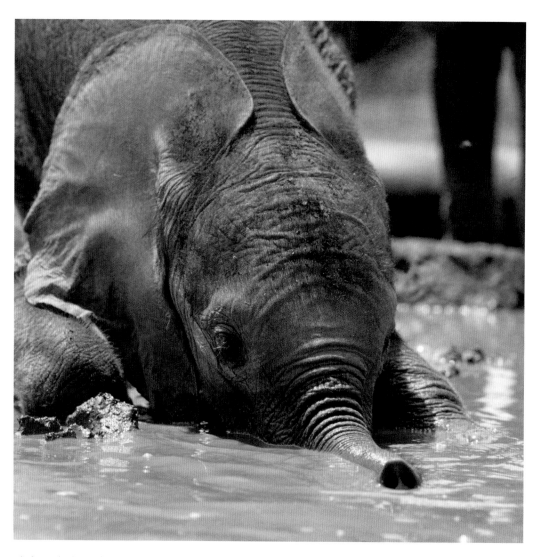

Oh dear – this little **African elephant** has not yet realised it can use its trunk for drinking water! Before too long it will come to master all the amazing things a trunk can do – but for now quenching thirst is paramount, no matter the method!

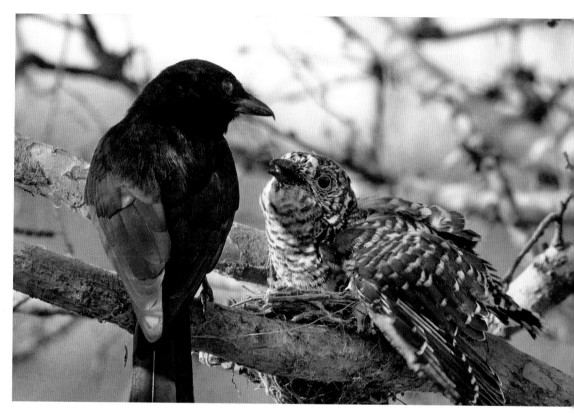

A poor **African drongo** has been duped into rearing this **African cuckoo** chick, almost too large for the nest now. It will continue to feed the cuckoo as if it were its own chick – and the crafty cuckoo chick ejected all the drongo eggs so there is no competition for food from other hungry mouths.

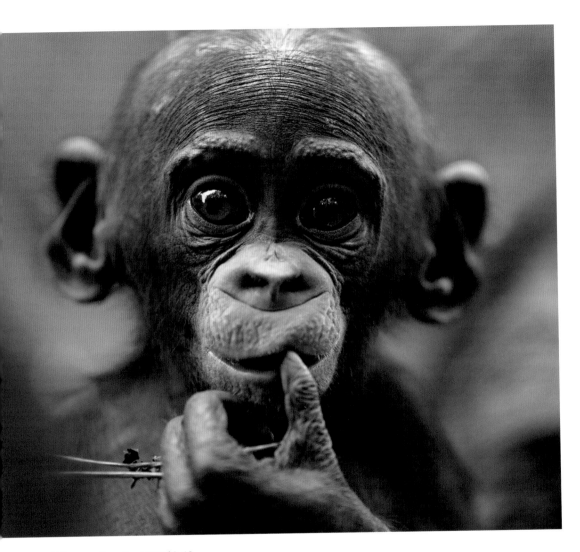

This young **Bonobo**, around 9–12 months old, has a largely vegetarian diet of fruit, leaves, shoots and bark but it will also feed on insect larvae, eggs and even the odd small mammal. A lot of food to discover!

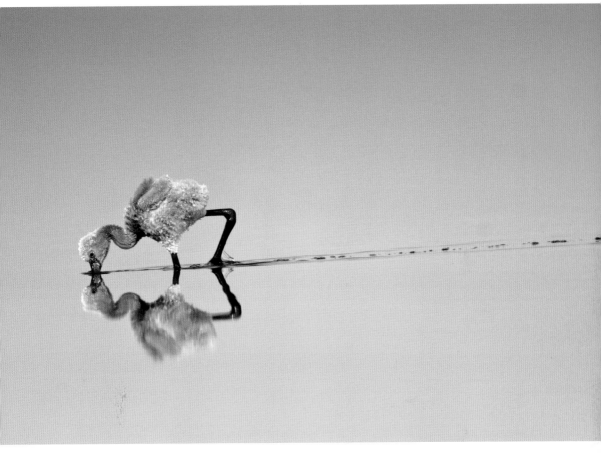

This **Lesser flamingo** chick is learning how to filter feed with its specialised beak. For the first few weeks the bill is straight but over time the curve develops and then the chick will venture to feeding grounds with a crèche of other chicks, led by experienced adults.

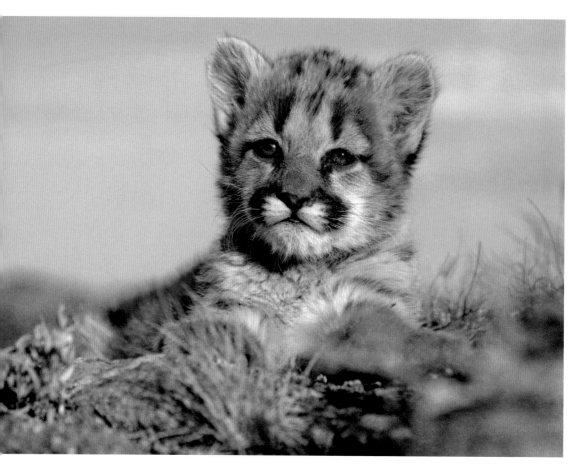

It's never too soon to start looking out for potential prey. This little **Mountain lion**, otherwise known as a **Cougar**, has piercing blue eyes but these will start to fade from 4 months of age and turn to golden brown by the time it reaches 16 months or so … the same time it will start looking for its own territory.

A **Giant panda** is ideally born in the autumn so that by the time it is ready to start eating bamboo, at around six months of age, the most nutrient-rich new shoots are out in spring. In the meantime it's fun learning how to climb trees whilst mum keeps on munching below!

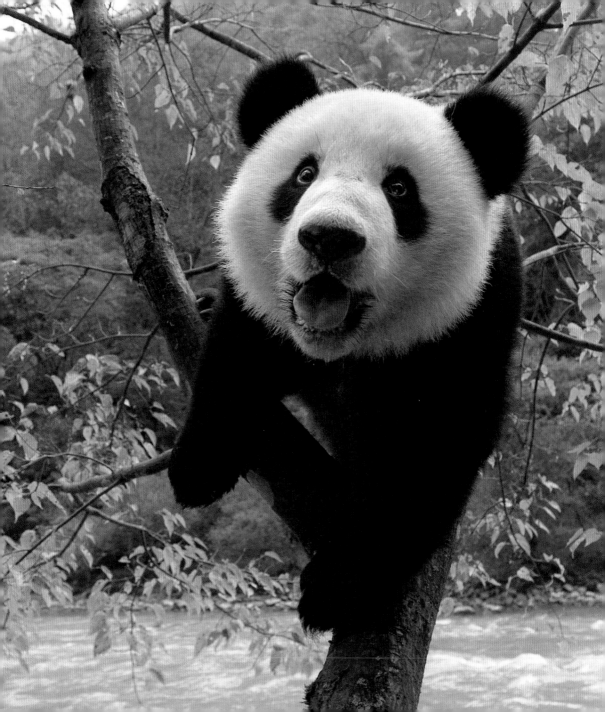

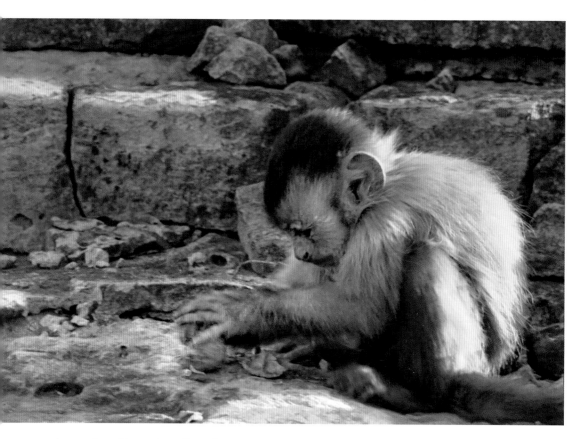

A young **Capuchin monkey** will spend
time observing adults use tools made of
rocks and wood as anvils to crack open
nuts before they attempt it themselves.
Then it will be a process of trial and error
before they successfully acquire the
skill – perseverance is key!

A baby **Giraffe** will start munching on leaves from around two months of age. As this giraffe grows – incredibly up to an inch a day – they will be able to reach higher branches and larger leaves but for now they have to watch the adults and reach where they can.

OVERLEAF
Unusually for canids, it is the father **Bat-eared fox** that provides most of the parental care – here he is teaching the pup how to find insect prey. These animals have an exceptional sense of hearing, using their extra large ears to amplify sound made by insects under the soil surface. Once heard, the fox will quickly dig up the soil and snatch up the prey with sharply pointed jaws.

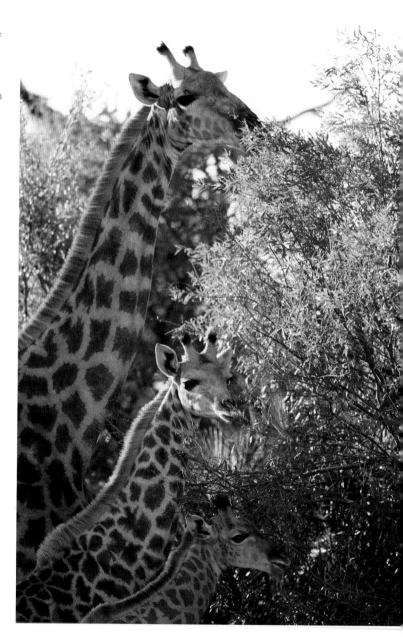

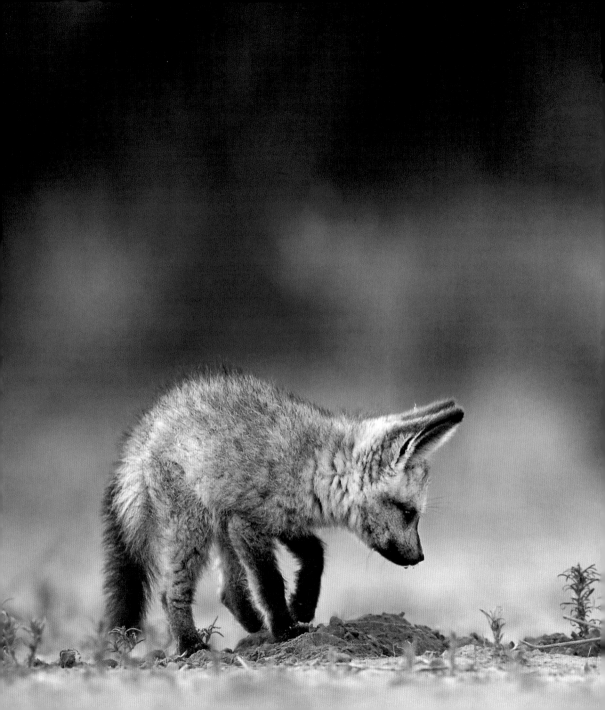

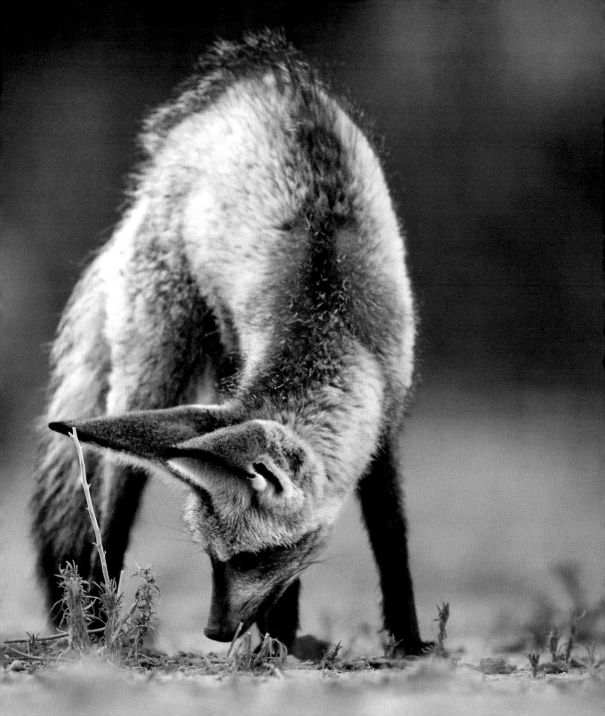

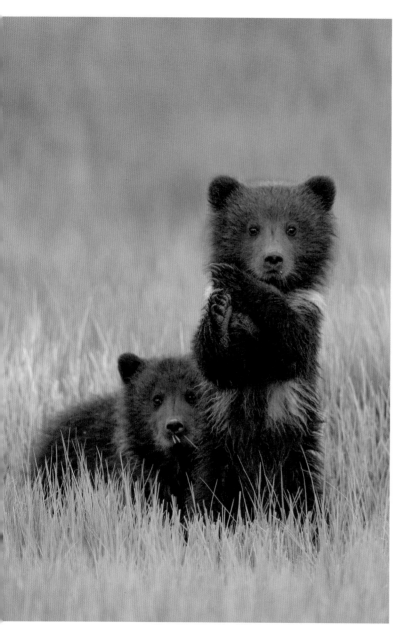

Two **Brown bear** cubs are feeding on summer meadow grass but still need to stay vigilant, ever on the look out for aggressive male bears that pose a real threat to their safety.

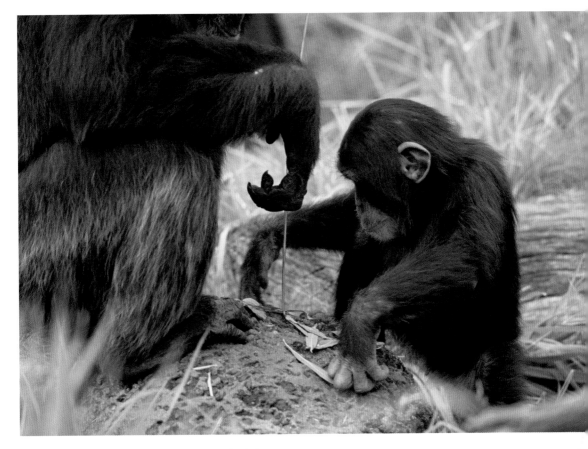

Just like humans, **Chimpanzees** utilise tools to make their lives easier. Here an adult chimpanzee is teaching a young male how to first strip a branch of leaves and then use it as a fishing tool to feed on termites. The youngster watches intently – it won't be long before it attempts insect fishing for himself.

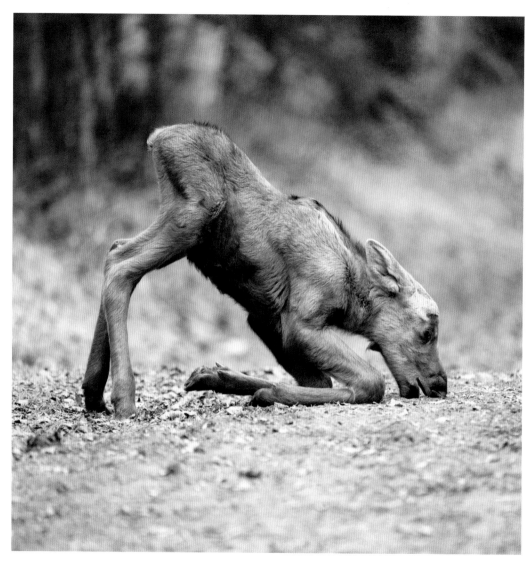

A young **Moose** calf kneels down to graze on vegetation.
It is thought that young moose learn what to eat from following
their mothers, but they only have one year in which to do so
when they are rejected before the female gives birth again.

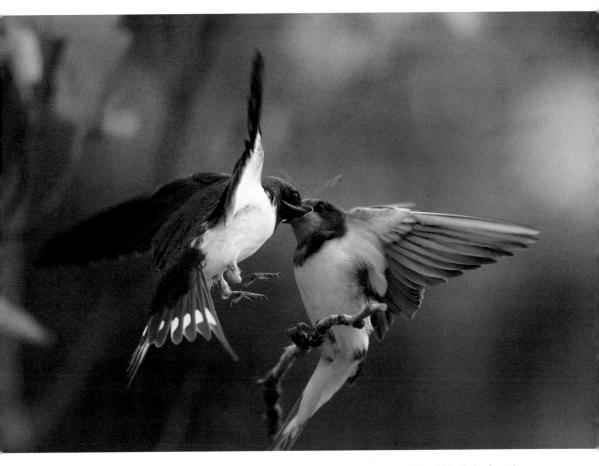

Barn swallow chicks fledge from the nest around three weeks of age – but the parents will still provide in-flight food such as seen here for another week before the chick is fully independent.

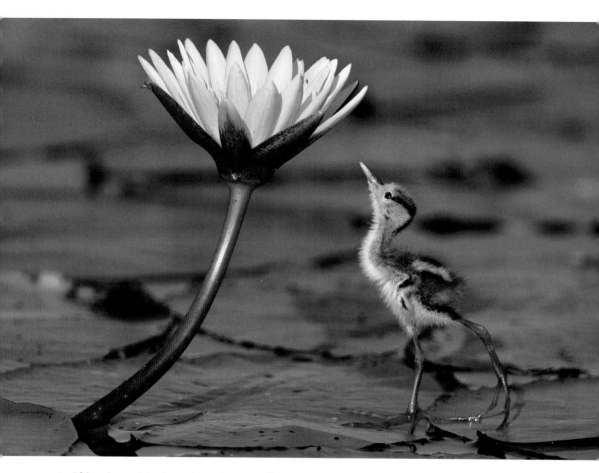

An **African jacana** intently watches an insect on a lily
flower – able to walk, swim and dive just a few hours after
hatching this chick is capable of feeding itself very soon in
life. Unusually it is the male jacana that teaches the chick
how to forage and provides all parental care and the
chick will remain with him for the first 60 days or so.

Mountain gorillas are generally herbivores, eating leaves, shoots, roots and fruits. However this little one is as interested in swinging from vines right now as consuming them – it's a playful age.

OVERLEAF
A little **Hippopotamus** calf rests in a lily-covered pool with its mother. The calf was actually born underwater and will spend most of each day submerged in water only coming out at sunset to feed on grass.

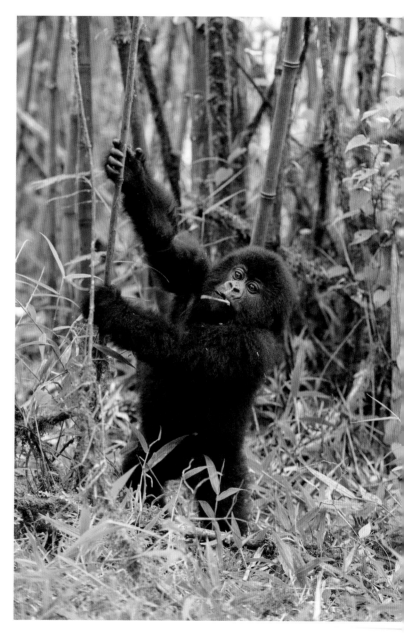

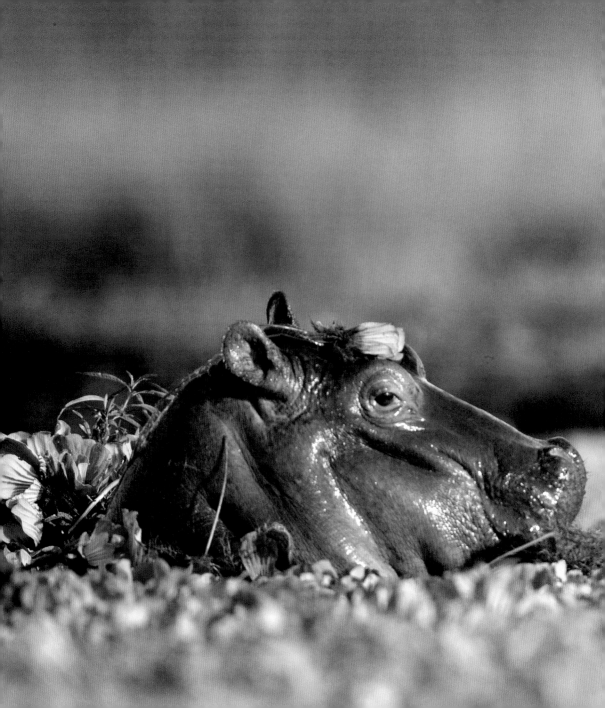

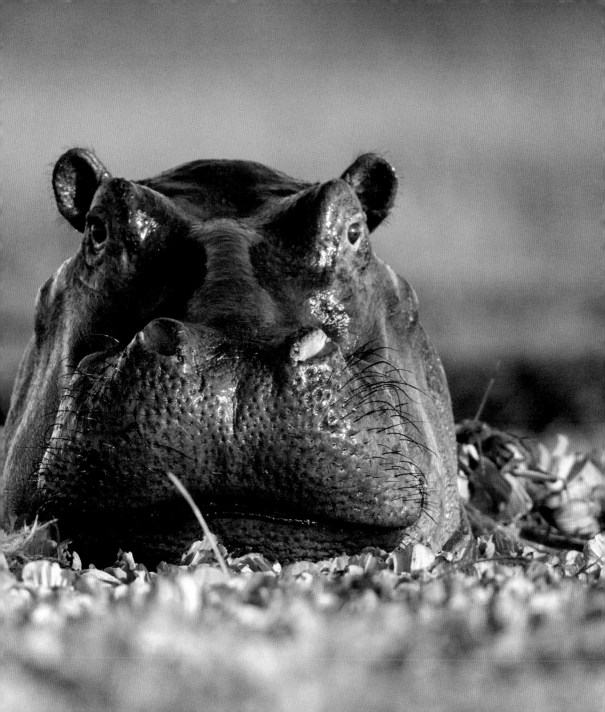

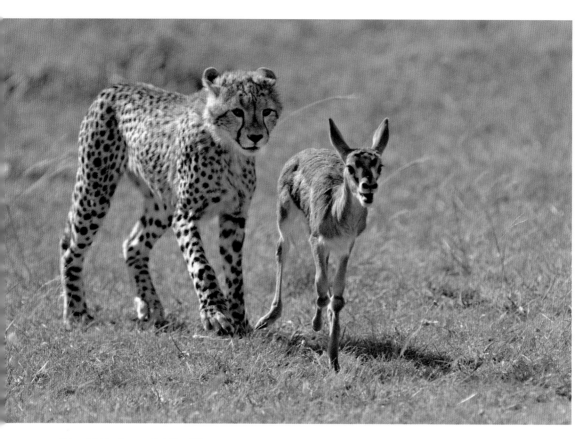

This might be the very first time this **Cheetah** cub has been presented with live prey, here a Thomson's gazelle fawn. It's a daunting task – to catch and kill dinner, but if the cub is to become independent and survive on the savannah it's the most crucial life skill to acquire.

A little male **Eastern chimpanzee** sits and plays with a fruit. Fruit is very much the preferred food source of chimpanzees but knowing when it is ripe enough to eat will result from playful curiosity and watching nearby adults.

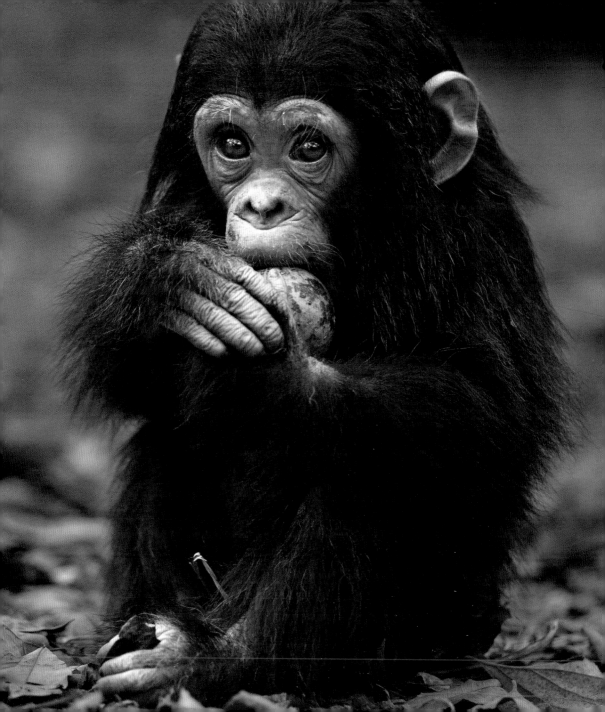

Making Friends

To survive to adulthood all animal babies need to learn life skills fast – and for a lot of them this involves making friends, some for a passing time, others for life.

When parents go out hunting, numerous babies are left in crèches, which offers ample opportunity for play and forming social bonds. Plus having others around you increases the chances of approaching dangers being spotted. Young **Geladas** grow up with plenty of mates to leap around with – but this play is the best way to hone their climbing skills, essential to living on steep ledges.

Agility will be key to **Fur seal** pups thriving in the open seas – and the best way to practise this is in nursery pools – chasing other energetic pups is a fun way to become a supremely confident swimmer.

Penguin chicks huddle together for warmth in cold spells as surviving the extreme cold necessitates getting close to your neighbour. **Lion** cubs have other social lessons to learn and need to understand the rules of the pride quickly – overstepping the mark is dangerous when dominant males are around.

Sibling rivalries are apparent from the start too with **Cheetah** cubs but all the playing is crucial to help them practise new skills essential for hunting and mating. For male cheetah cubs forming strong bonds with brothers could be the key to survival – one day they will be pushed away from the family and instead of striking out alone they stand a better chance of survival by forming a coalition together.

Although all this play might just seem like fun it actually helps teach the fundamental skills for survival and lays down the lessons for adult life.

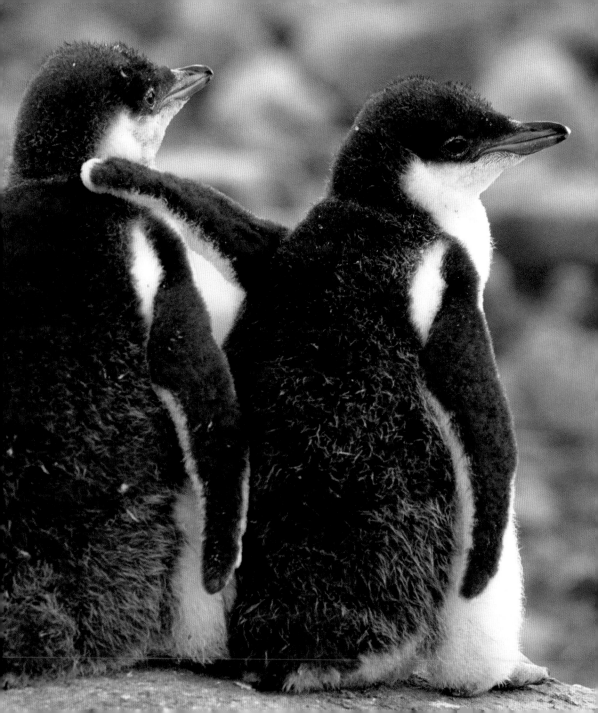

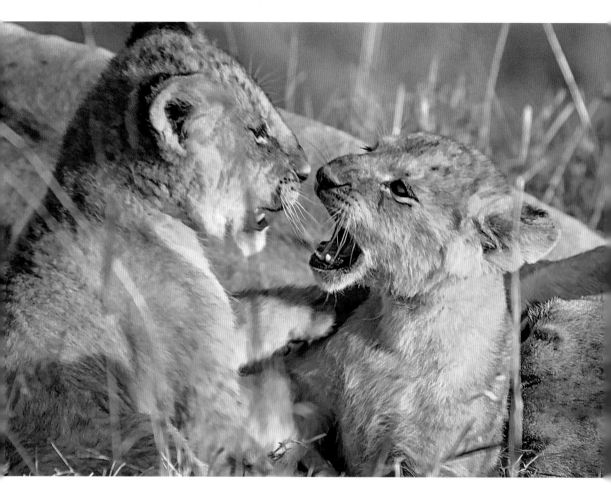

Lions are the only true social cats having close-knit families that benefit from group hunting techniques. These two cubs may be working out their pecking order within the family, learning important social cues to help them avoid confrontation as they grow older.

A juvenile **Golden snub-nosed monkey** and an infant cuddle up together to keep one another warm – it's cold up in the mountains. Even allowing for their beautiful thick fur, it's important to conserve energy where possible as well as seek comfort through the night.

OVERLEAF
Right now all these two **Polar bear** cubs want to do is chase one another! They will remain with their mother for at least another year but then will disperse and have to find their own territories.

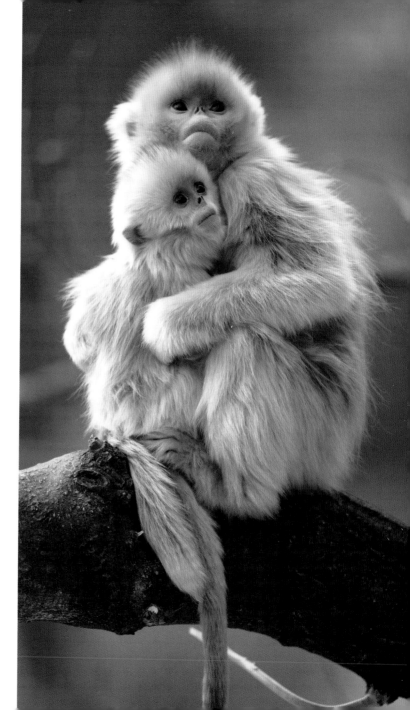

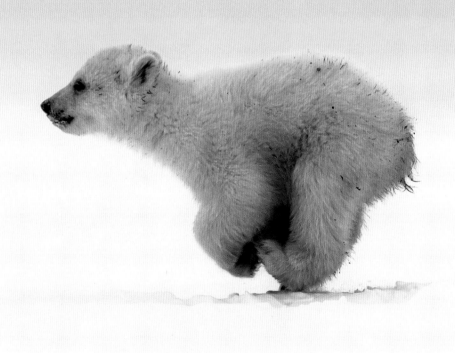

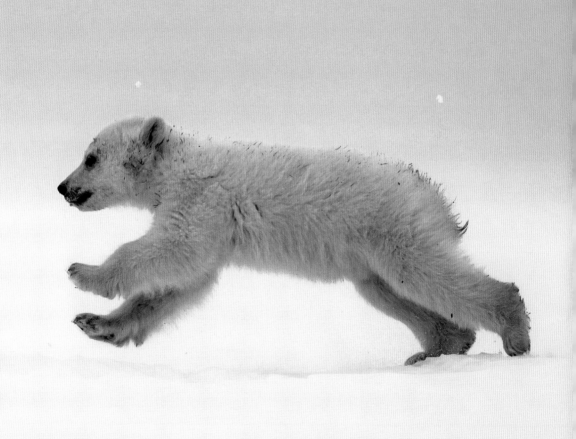

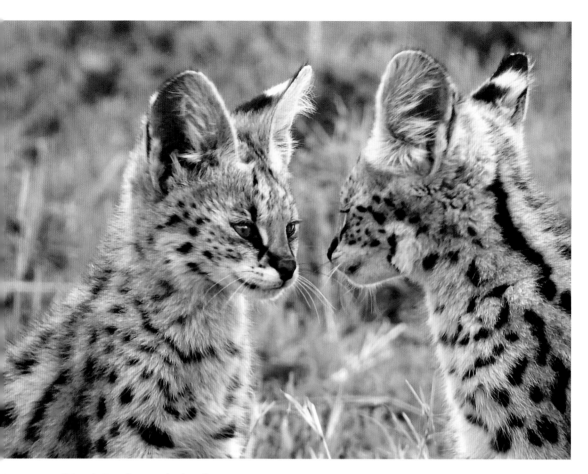

Although **Serval** cats tend to be solitary as adults, for now these two kittens have each other for company and can test their growing hunting and social skills on one another – both of which will be vital when it's time for them to go their own way.

These adorable **African elephant** calves look to be displaying affectionate friendship as they hold trunks and walk alongside one another. Their trunk serves as a human hand would – in fact the tip is far more sensitive than our fingertips – and they use them to reach out, touch and caress other herd members, helping to form and maintain close bonds.

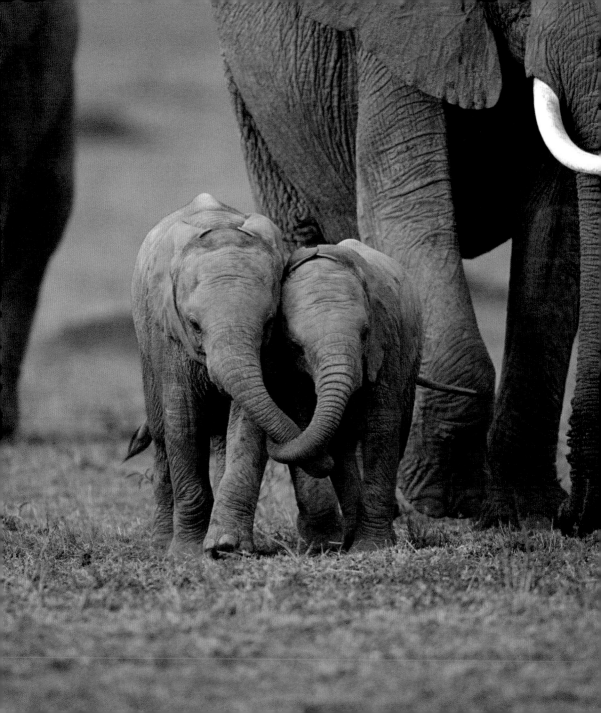

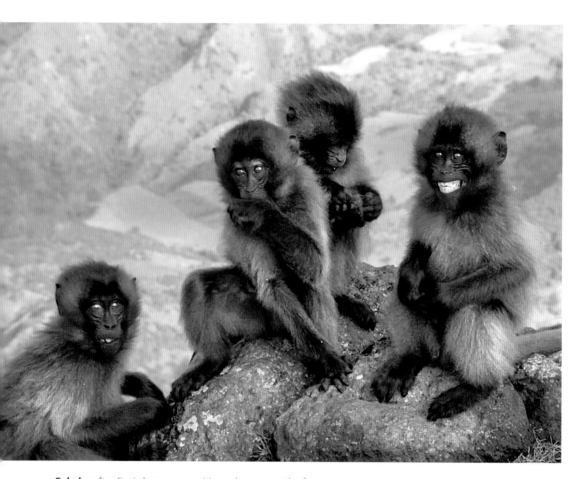

Geladas often live in large communities and consequently often use visual signals to communicate effectively with many individuals at the same time. These might include facial expressions and body posture and this group of young are practising their social signals amongst themselves, and will continue to develop more from watching and copying adults around them.

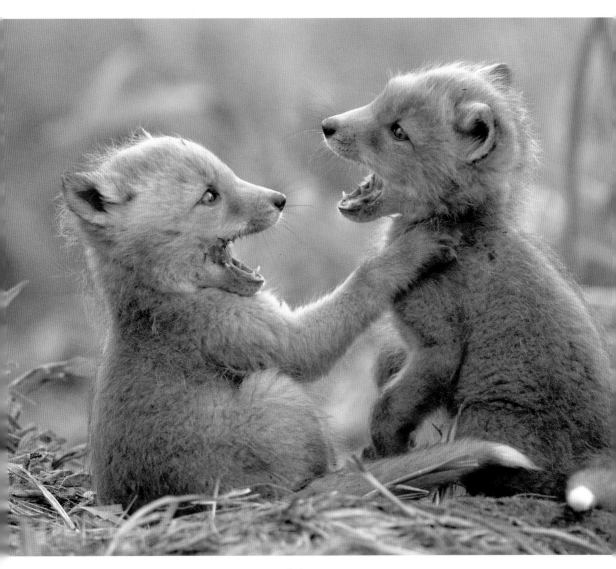

Red fox cubs engage in a round of play fighting – this will help develop life skills for hunting and mating. It is only a temporary friendship however as these same cubs will strike out alone and find their own territory rather than stay together.

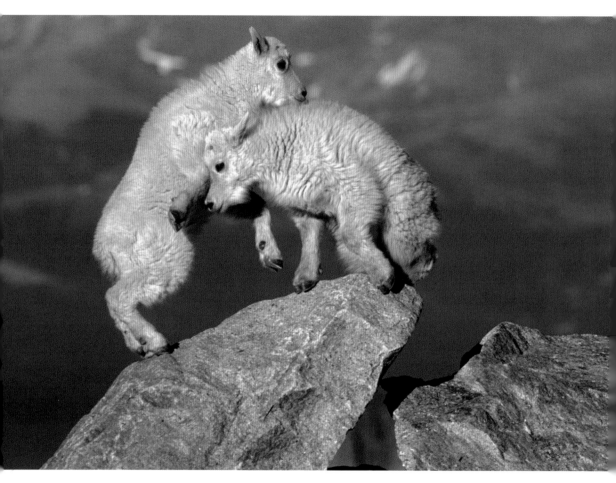

There is a strong social structure within **Mountain goat** herds and kids tend to assume the status of their 'nanny' (mother). Every goat will show some aggression towards lower ranked members and so this type of play fighting serves the purpose of working out who fits where in the overall hierarchy and which individuals are good to have as allies.

A couple of **Welcome swallow** fledglings huddle together in the rain, waiting for a parent to bring them some food. Even though they have fledged the nest, the parents will still provide food for another week and even tempt the young back to the nest each night. However it won't be long before these two fly solo …

OVERLEAF
It will be around 16–18 months when **Cheetah** cubs leave their mother, or indeed are pushed away. After this time littermates may stay together for a few months more, helping one another perfect hunting skills, but then any female cub will reach sexual maturity and will leave siblings and start a solitary life. Any brothers however will most likely form a 'coalition' either temporarily or for life.

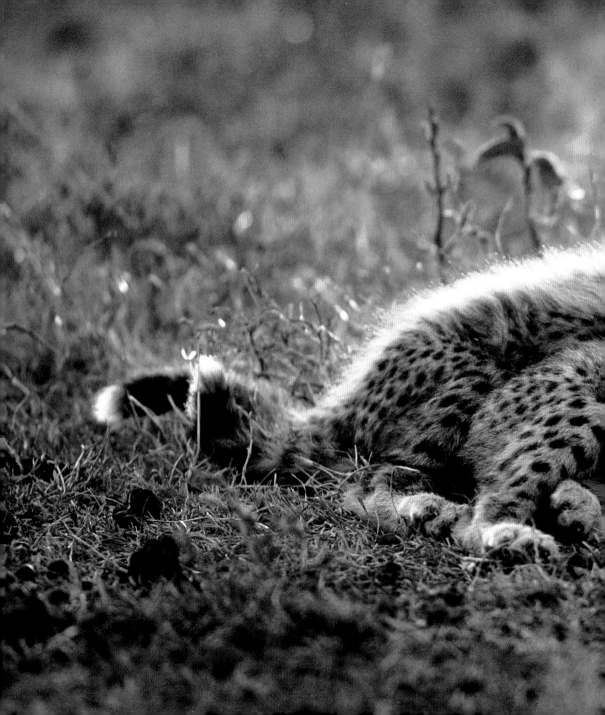

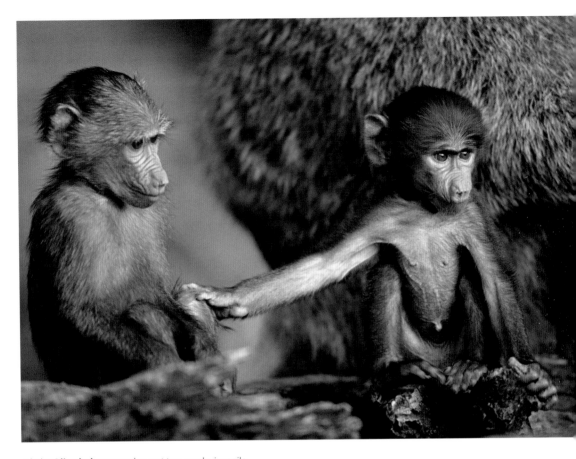

A baby **Olive baboon** reaches out to a nearby juvenile. Primates are highly social creatures and physical contact is a very important factor in their development – they use gestures such as this to reinforce bonds between individuals, promote harmonious group living and, like humans, communicate their feelings.

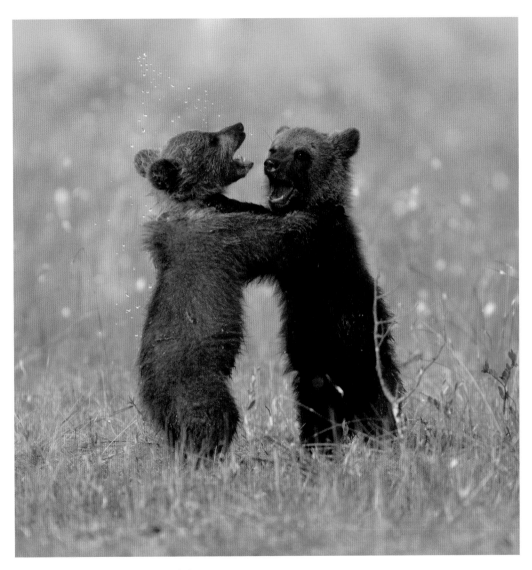

It may look like good clean fun but play fighting amongst siblings and testing one another's strength is the best way for animal babies such as these **European brown bears** to practise fighting skills that will come in good use in later years.

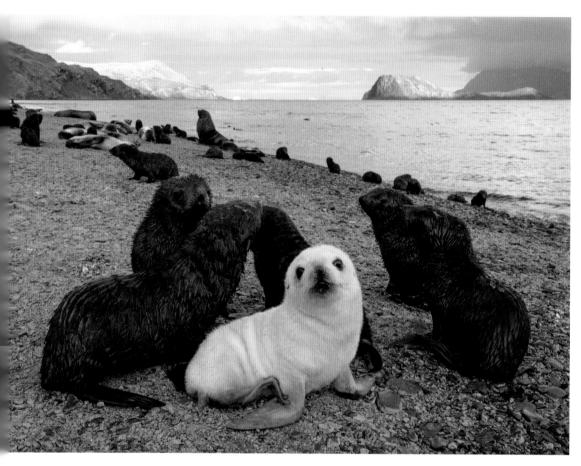

A small group of **Antarctic fur seal** pups interact and sit together on the beach whilst their mothers are at sea feeding. This leucistic pup definitely needs allies around it as the pale pelt makes it more obvious to potential predators such as Leopard seals. One in every hundred pups born has this abnormal coloration.

Despite being born in one of the coldest places on Earth these **Emperor penguin** chicks have a natural urge to huddle together to keep warm. This same group-cuddle instinct also means that they do not defend any territory – the only species of penguin not to do so.

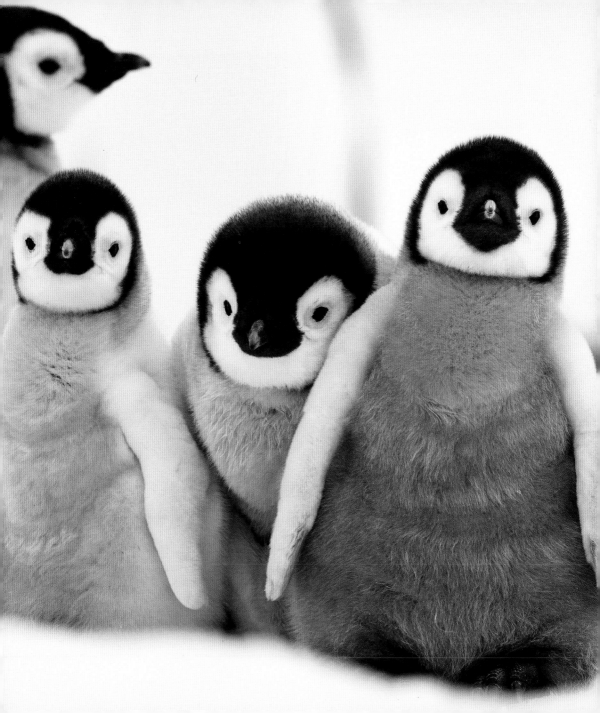

These baby **African elephants** are all touching and wrapping their trunks around the one on the ground in excitement as well as being a sign of affection and perhaps offering comfort. Their friendships may be all about fun right now but as they grow older they will continue to communicate with one another using a mixture of physical gestures as well as complex vocalisations.

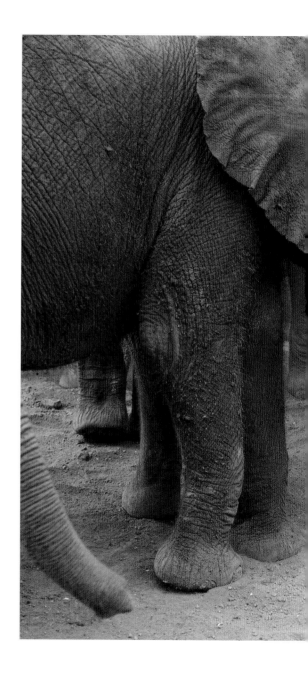

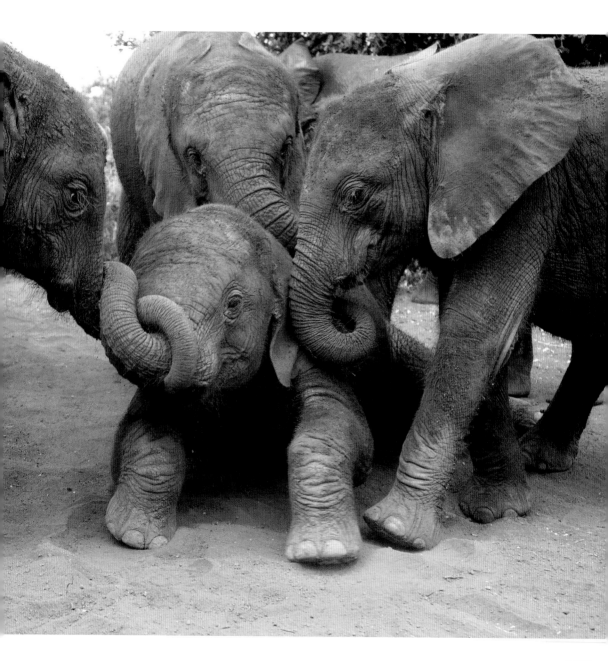

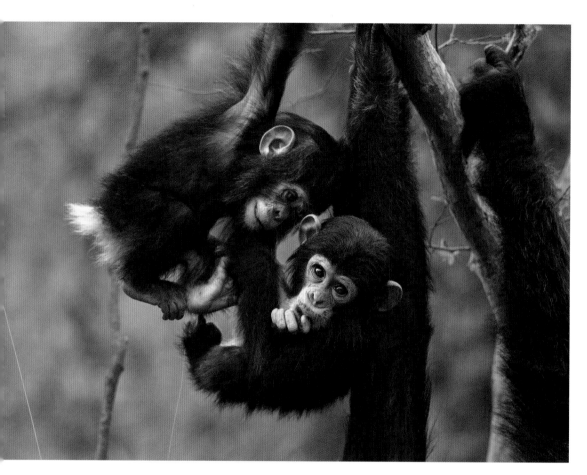

These two **Chimpanzee** babies are having a lot of fun swinging from the branches! It's not all play however – they have a lot to learn about social relationships, build on their physical abilities and discover all about their habitat and so rough play like this helps on all fronts.

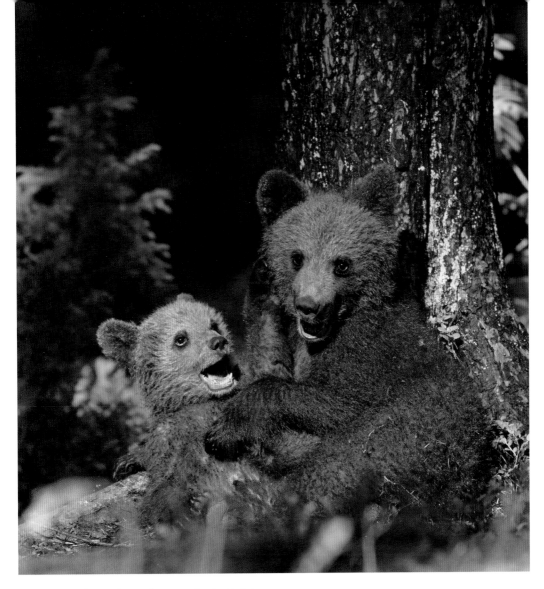

Two **European brown bear** cubs engage in a bout of play fighting. For now they are great play mates but it is unlikely this will continue as they reach independence as bears don't live in extended family groups and tend to socialise with other unrelated bears rather than siblings, if at all.

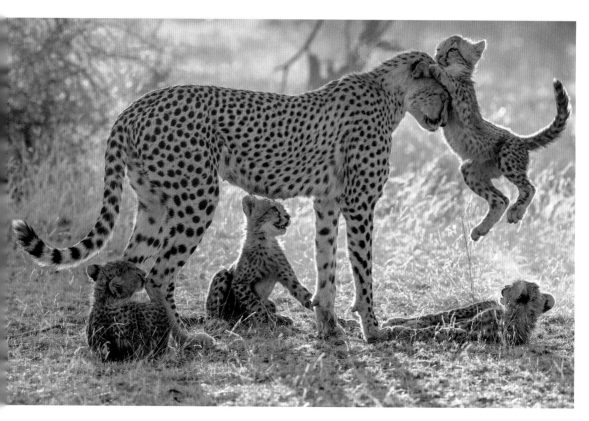

Four lively **Cheetah** cubs enjoy playing not only with one another but also with their mother – fine-tuning their chasing, jumping and wrestling skills that will be crucial to become efficient hunters one day. Some of these cubs may stay together after separating from their mother – and these early playful days will reinforce such bonds.

Indian foxes rarely have more than two cubs at a time so this pair only has one another for playful company and to pick up social skills. Dispersal will happen around four months of age, a very quick 'childhood', but it is timed for the monsoon when there will be plentiful prey for the newly independent foxes.

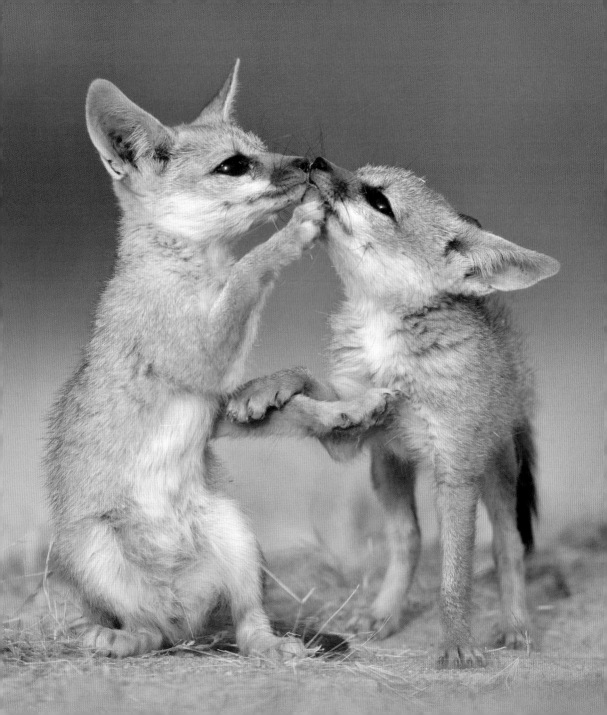

Rites of Passage

It's not an easy road to adulthood – wherever they live in the world – but independence is the ultimate goal. All animal babies have to learn and adapt the skills needed to thrive in their environment and as quickly as possible.

For **Elephant** calves it will be many years before they no longer rely on mum, but it takes a long time to learn how to survive changing seasons and commit to memory all the home range – which could be thousands of kilometres in size!

Young birds however have the ultimate rite of passage far sooner – to fledge. Chicks flap their wings in preparation, strengthening the muscles, honing the technique day after day, but inevitably it will be one huge leap of courage to fly from the nest – in the case of **Gyrfalcons** a step off the ledge – and take to the air.

The aquatic babies, like **Fur seals**, born on land and initially clumsy and awkward will be perfectly at home once they enter their watery world. Those babies born into large herds such as **Zebra** and **Wildebeest** need to develop speed and stamina quickly or else they will be left behind. Making your own bed sounds simple enough but it takes a baby **Mountain gorilla** a long time to watch, practise and refine the technique to keep him warm through the wintery nights.

Learning to catch a slippery fish, mastering your trunk or beak, taking that first step unaided into the open sea – it's all a lot to learn and not all animal babies will succeed.

But those who do will go forward into adulthood and stand a chance of raising their own babies one day.

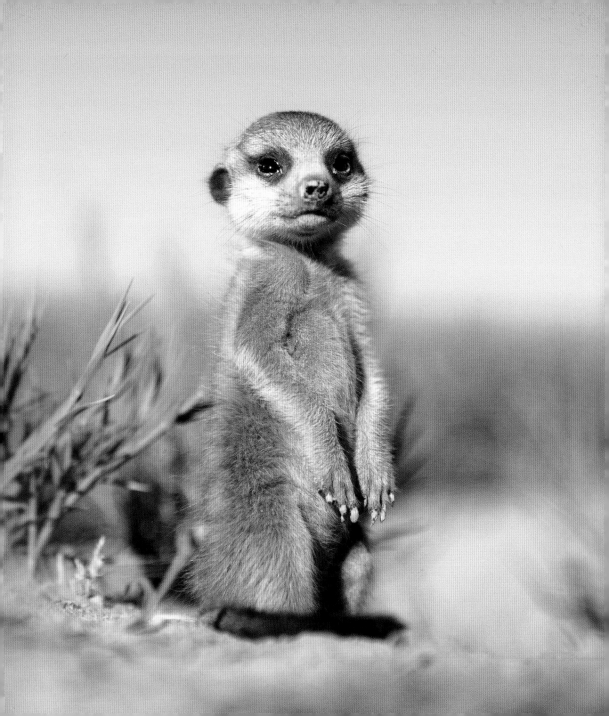

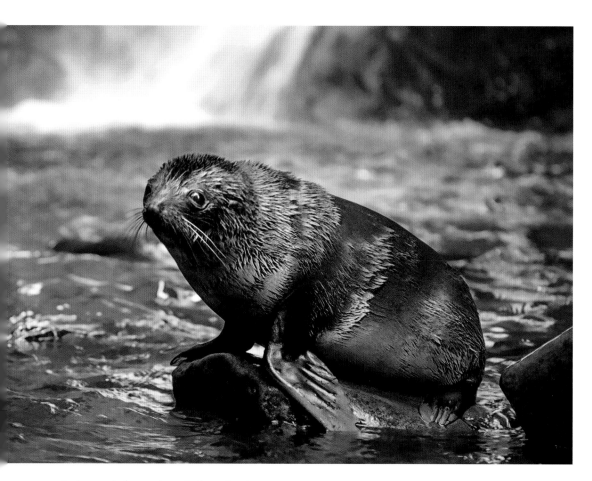

Having spent a few weeks perfecting swimming acrobatics in this inland nursery pool, this **Fur seal** pup is now ready to return to the beach and head out to sea for the very first time.

Another young yearling, this time a **Polar bear,** leaps into the water. Polar bears are considered marine mammals as they have adapted to a life in the ocean and also depend on it for food.

OVERLEAF
Very soon all these **Emperor penguin** chicks will be left together on the sea ice. Their parents will no longer return to feed them and the chicks must start to walk to the sea edge and then wait for their downy feathers to moult, revealing their waterproof feathers. Then, and only then, can they head out to sea for the very first time.

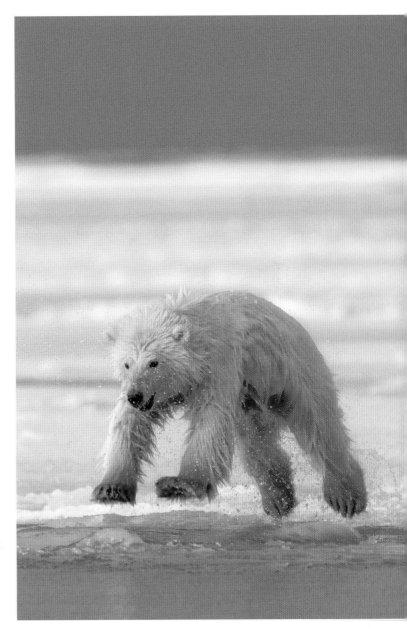

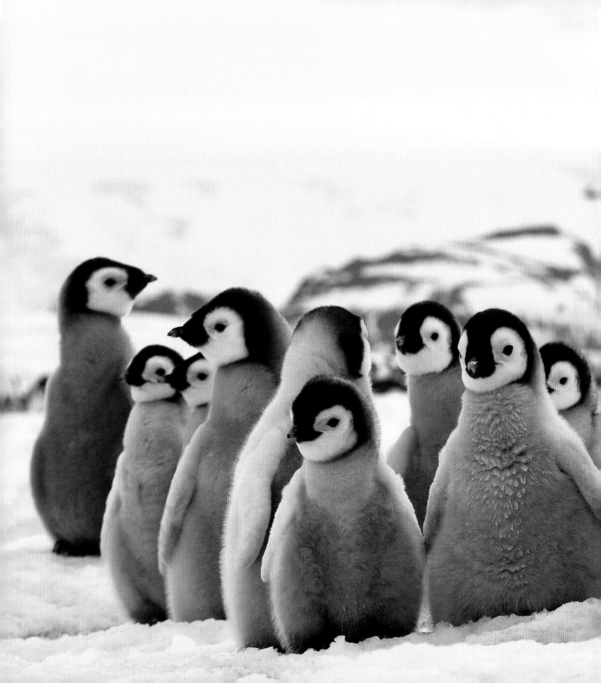

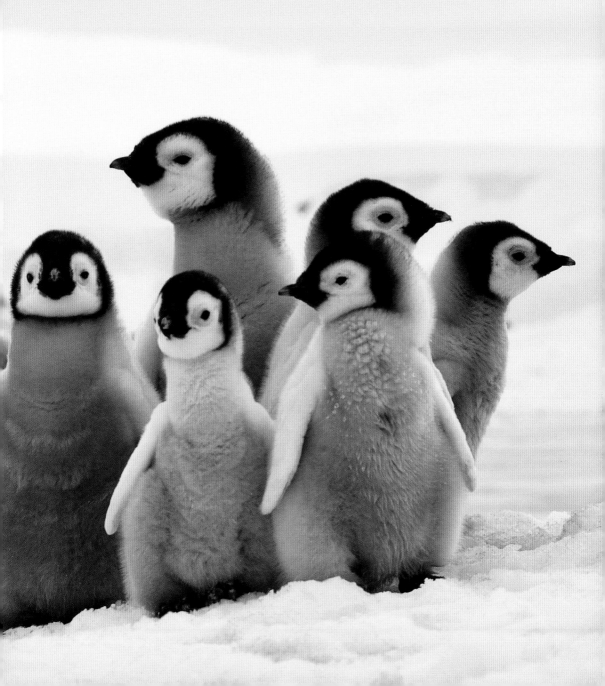

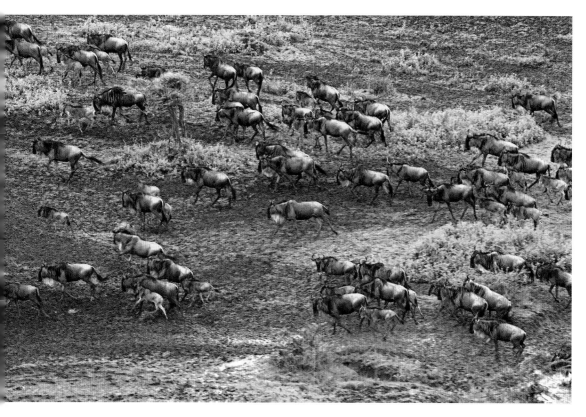

Another animal baby has made it –
a **Wildebeest** calf joins hundreds of
adults and other calves on the search
for new shoots to eat. It will need
strength and stamina to keep up with
the herd as well as outrun any predators
lying in wait and it will continue this
annual migration for the rest of its life.

It depends on whether a **Common zebra**
foal is male or female as to what happens
after they are weaned. Females can stay
in harem groups with their mother, under
one dominant stallion. Males will have
to join a bachelor group until old enough
to challenge a breeding stallion.

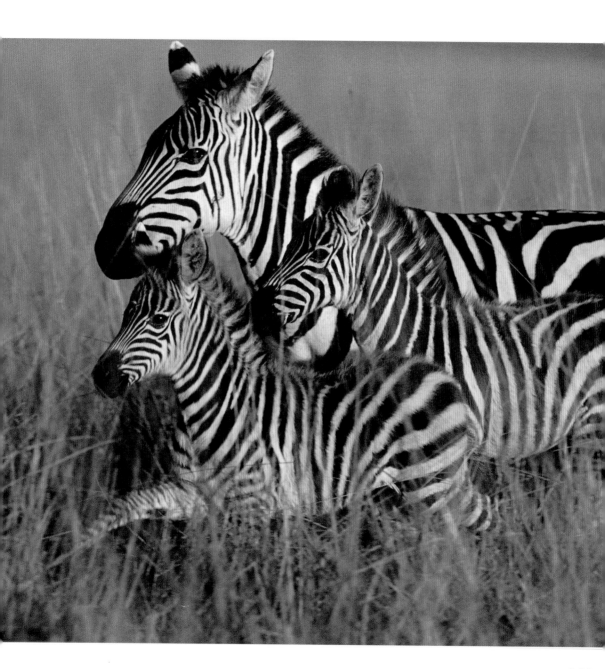

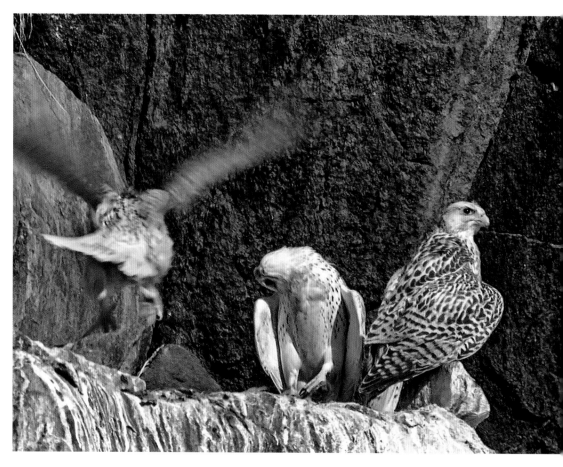

Gyrfalcon chicks are born literally on the edge of a rock face – so when they start preparing to fledge they have no choice but to flap their wings, jump up a few times … and then take the plunge and dive off into the void. Some look more ready than others!

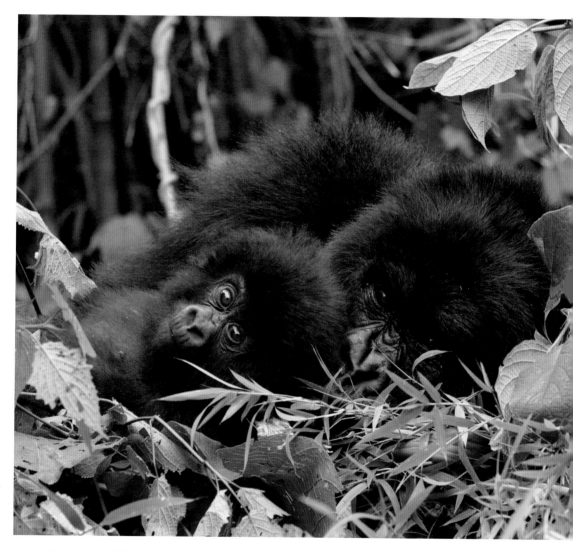

For now this one year old **Mountain gorilla** is able to share a nest but over the next few years they will keep watching the adults create theirs and start to copy until, one day, they too will be pulling branches and leaves together to make a comfortable bed for the night.

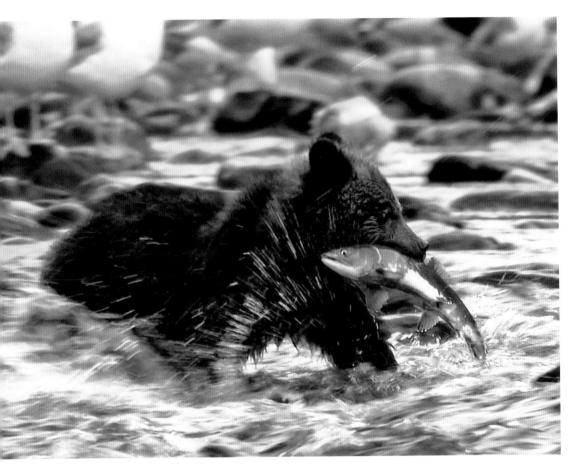

The ultimate rite of passage for this **Grizzly bear** cub – it has caught its own fish for the first time!

Although these two **Grizzly bear** cubs will probably remain with their mum until 2–3 years of age, they have reached a new level of independence by swimming across rivers now, rather than hitching rides on the female's back as before.

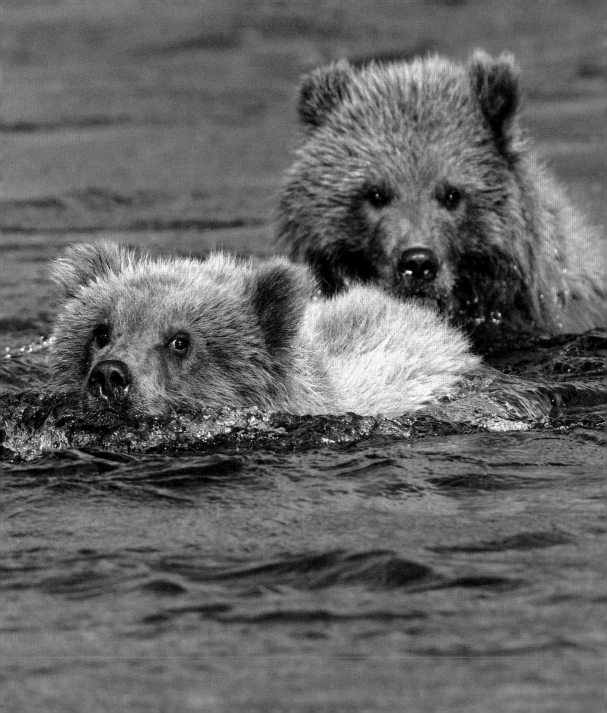

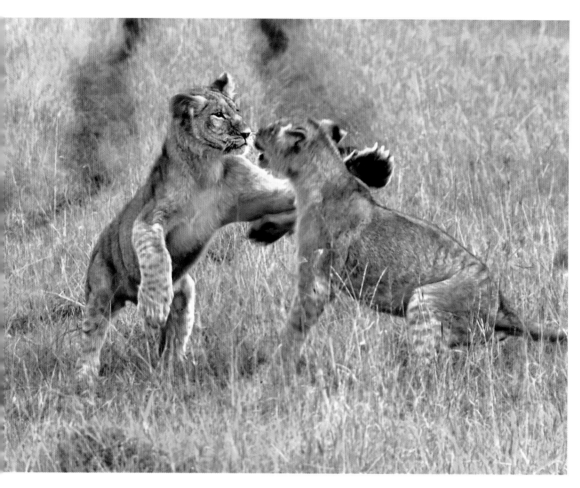

The play boxing seen here between two young **Lions** is beginning to take on a more serious note. What used to be carefree playfulness is now more about fine-tuning fighting skills and testing strength levels. Female cubs can remain with their maternal pride, but male cubs will soon be ousted and will need to find their own way.

A young **Mountain gorilla** has been watching the adult males beat their chests – and is now having a very good go himself! It will be many years before he both masters the technique and needs to perform it, but for now imitation is the greatest form of flattery!

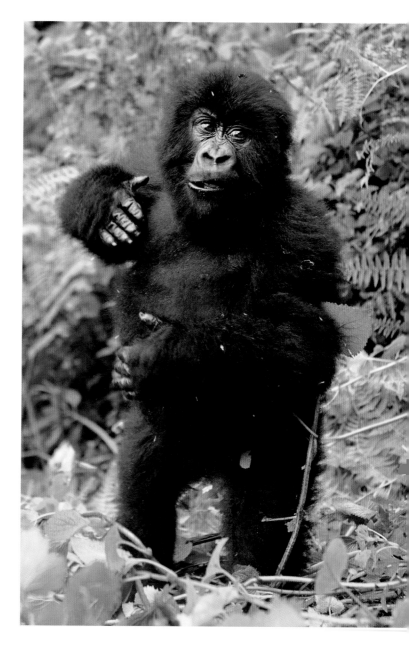

OVERLEAF
This **African elephant** calf has mastered another use of its trunk – as a snorkel as it swims across a deep river with its mother.

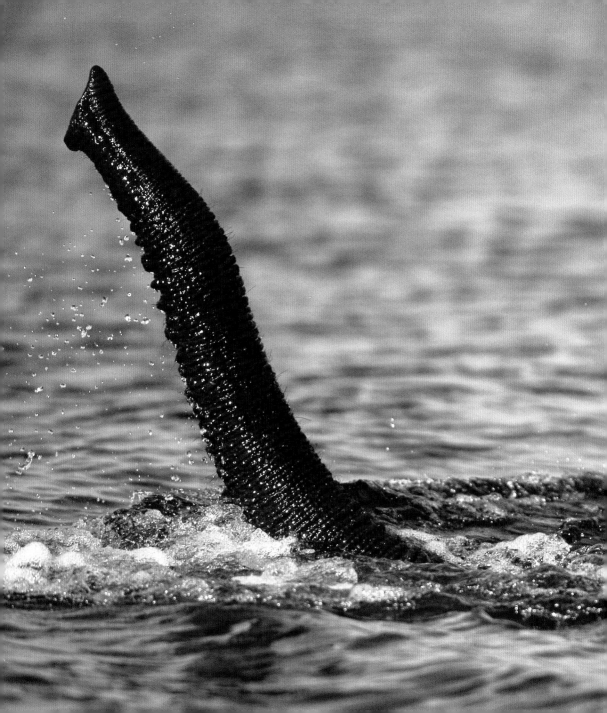

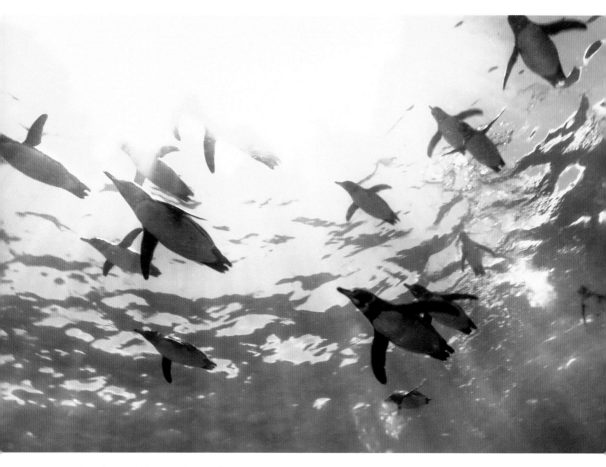

Born in underground burrows these **Galapagos penguin** chicks have finally fledged and dive beneath the waves. Where they were once clumsy on land, waddling on feet with outstretched wings, once in the water they are superb swimmers.

When this **Giant panda bear** was born it was the smallest mammal newborn relative to the size of its mother. In just a few months it has gone from being blind, hairless and hapless to being a confident climber, avid explorer and as much a devotee of bamboo as any Giant panda. It isn't quite independent yet – but it's grown up an awful lot!

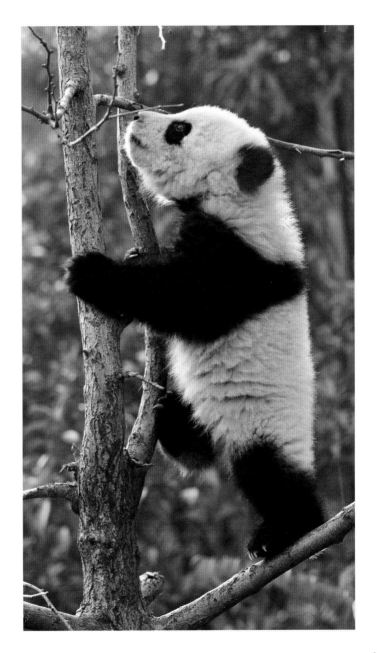

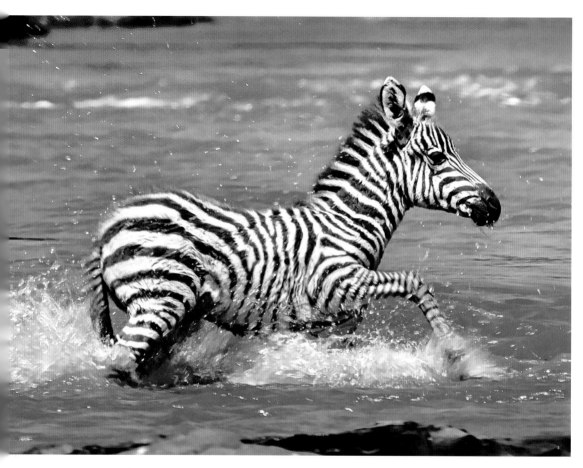

A **Common zebra** foal safely makes it across the river.
It will have to cross rivers such as this every year in the quest
for fresh grass and each time the challenges will remain the
same – fast flowing water combined with hungry crocodiles.
Next year however it won't have its mother around for
guidance – but it's unlikely to be alone.

At last the baby white fur has moulted and this young **Baikal seal** has a much darker coat and is ready to investigate the water. However this is not the sea – this seal species is the only one to live entirely in freshwater, in Lake Baikal, the deepest lake in the world.

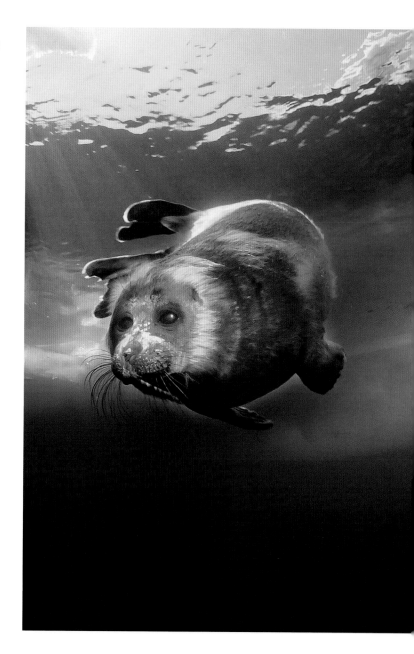

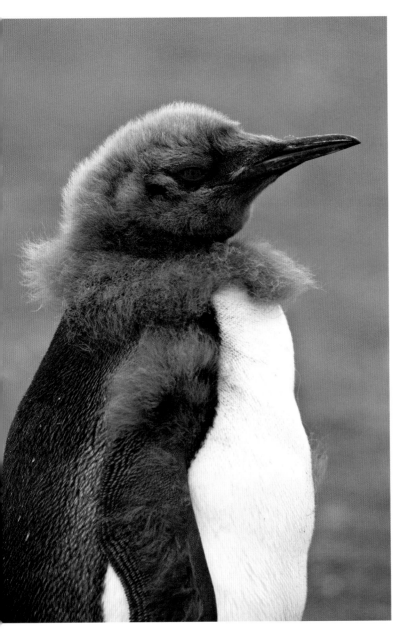

Due to their large size it is over a year before **King penguin** chicks are ready to fledge and they have one last important stage to go through before they can … they need to moult. The down feathers that were so imperative for keeping them warm are a very poor insulator when wet so they go through a somewhat comical transition to adult plumage. Only then are they ready to go to sea!

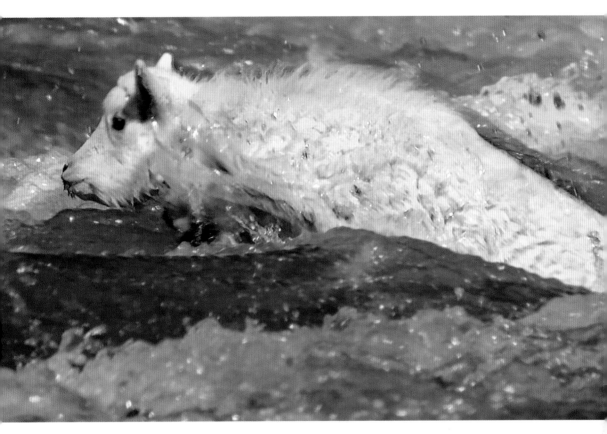

To reach vital minerals that only occur on certain cliffs this
Mountain goat kid has one last challenge to face – crossing
a turbulent river. It has survived coming down the steep rocky
gradients, it has avoided hungry bears, wolves and eagles,
it has learnt to run and jump – but now can it swim as well?

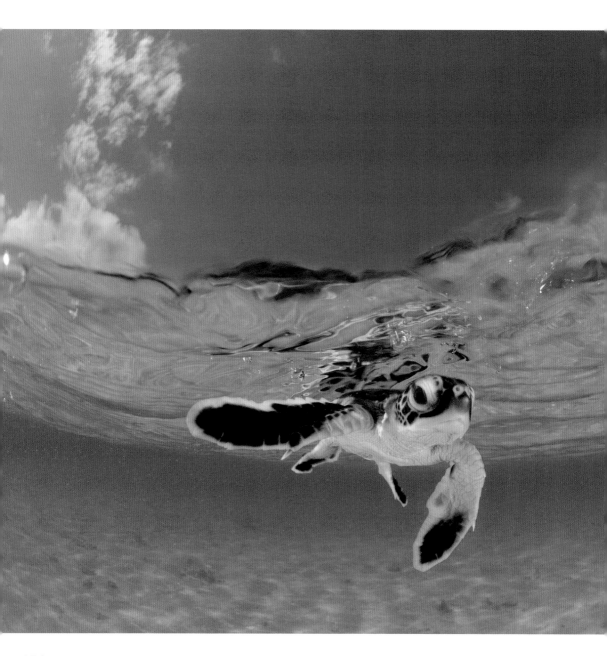

A **Green turtle** hatchling has made it to the sea – and so starts a life in the water. She won't return to land until she herself is ready to lay eggs on the very same beach on which she was born.

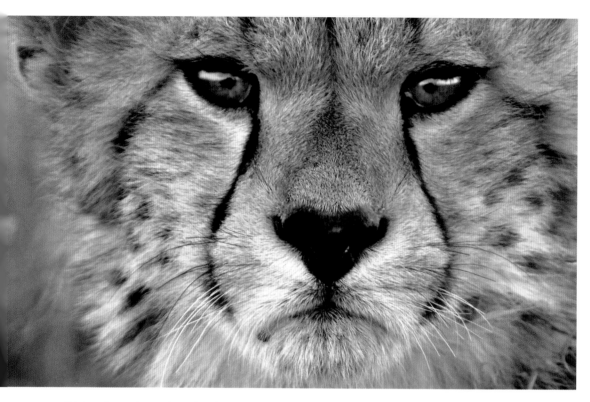

This is no longer the cute face of a cub wanting to play – this **Cheetah** has the intent look of a predator. The final rite of passage is to bring down live prey for itself and become fully independent.

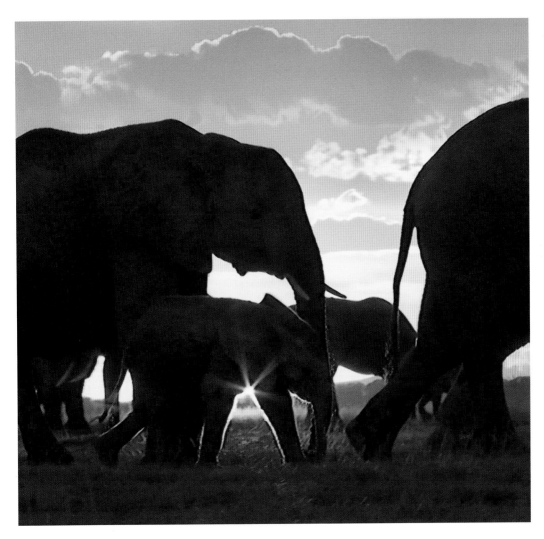

African elephant calves experience one of the longest childhoods in nature. It could be ten years before this calf is fully weaned but the kinship of the herd and high level of social contact is crucial to help it continue to develop and learn both survival skills and cultural knowledge, passed down from old to young.

Picture credits

6–7 Erlend Haarberg/NPL; **9** Suzi Eszterhas/MP/FLPA; **10–11** Lou Coetzer/NPL; **12** BBC; **13** Kevin Schafer/MP/FLPA; **14** Katherine Feng/MP/FLPA; **15** Donald M. Jones/MP/FLPA; **16–17** Momatiuk & Eastcott/MP/FLPA; **18** Nick Garbutt/NPL; **19** Frans Lanting/FLPA; **20** Laurent Geslin/NPL; **21** Mattias Breiter/MP/FLPA; **22–23** Edwin Giesbers/NPL; **24** Suzi Eszterhas/MP/FLPA; **25** BBC; **26** Andy Rouse/NPL; **27** Anup Shah/NPL; **28** Fiona Rogers/NPL; **29** BBC; **30–31** Robin Hoskyns/Biosphoto/FLPA; **32** Mitsuaki Iwago/MP/FLPA; **33** Ingo Arndt/MP/FLPA; **35** George Sanker/NPL; **36** BBC; **37** Suzi Eszterhas/NPL; **38–39** Claudio Contreras/NPL; **40** Jan Vermeer/MP/FLPA; **41** Denis-Huot/NPL; **42** BBC; **43** BBC; **44** Sven Zacek/NPL; **45** BBC; **46–47** Ingo Arndt/MP/FLPA; **48** BBC; **49** Ingo Arndt/NPL; **50** AFLO/NPL; **51** BBC; **52** BBC; **53** BBC; **54** Jonathan Harrod, Hedgehog House/MP/FLPA; **55** Peter Cairns/NPL; **56** Richard du Toit/MP/FLPA; **57** BBC; **59** Anup Shah/NPL; **60–61** Ingo Arndt/NPL; **62** BBC; **63** Suzi Eszterhas/MP/FLPA; **64** Bernard Castelein/NPL; **65** Gerard Lacz/FLPA; **66** Anup Shah/NPL; **67** BBC; **68** Jussi Murtosaari/NPL; **69** Klein & Hubert/NPL; **70** BBC; **71** Mark MacEwen/NPL; **72–73** Anup Shah/NPL; **74** ZSSD/MP/FLPA; **75** BBC; **76** BBC; **77** Visuals Unlimited/NPL; **78** Klein & Hubert/NPL; **79** BBC; **80** BBC; **81** Frans Lanting/FLPA; **82–83** Erlend Haarberg/NPL; **85** Ariadne Van Zandbergen/FLPA; **86** Fiona Rogers/NPL; **87** Suzi Eszterhas/MP/FLPA; **88–89** Robin Hoskyns/Biosphoto/FLPA; **90** Gerry Ellis/MP/FLPA; **91** BBC; **92** Anup Shah/NPL; **93** Anup Shah/NPL; **94** ARCO/NPL; **95** Mitsuaki Iwago/MP/FLPA; **96** BBC; **97** Pete Oxford/NPL; **98–99** Vincent Grafhorst/MP/FLPA; **100** Ingo Arndt/MP/FLPA; **101** Gerry Ellis/MP/FLPA; **102** Steven Kazlowski/NPL; **103** Markus Varesvuo/NPL; **104** Lou Coetzer/NPL; **105** Suzi Eszterhas/MP/FLPA; **106–107** Anup Shah/NPL; **108** Andy Rouse/NPL; **109** Fiona Rogers/NPL; **111** Flip de Nooyer/MP/FLPA; **112** BBC; **113** Cyril Ruoso/MP/FLPA; **114–115** Meril Darees & Manon Moulis/Biosphoto/FLPA; **116** BBC; **117** Anup Shah/NPL; **118** BBC; **119** Igor Shpilenok/NPL; **120** Shattil & Rozinski/NPL; **121** Brent Stephenson/NPL; **122–123** Anup Shah/NPL; **124** Anup Shah/NPL; **125** Danny Green/NPL; **126** Imagebroker/FLPA; **127** J.-L.Klein&M.-L.Hubert/FLPA; **128–129** Lisa Hoffner/NPL; **130** Fiona Rogers/NPL; **131** Marko Konig/Imagebroker/FLPA; **132** Klein&Hubert/NPL; **133** Sandesh Kadur/NPL; **135** Will Burrard-Lucas/NPL; **136** BBC; **137** Steven Kazlowski/NPL; **138–139** Klein&Hubert/NPL; **140** BBC; **141** Anup Shah/NPL; **142** BBC; **143** Suzi Eszterhas/MP/FLPA; **144** BBC; **145** Diane McAllister/NPL; **146** BBC; **147** Andy Rouse/NPL; **148–149** Richard du Toit/MP/FLPA; **150** BBC; **151** Andy Rouse/NPL; **152** BBC; **153** Olga Kamenskaya/NPL; **154** J.-L.Klein&M.-L.Hubert/FLPA; **155** BBC; **156–157** Jurgen Freund/NPL; **158** BBC; **159** BBC

NPL – naturepl.com; **MP/FLPA** – Minden Pictures/Frank Lane Picture Agency